UNDER THE FIG TREE

Time to go...One Last Coffee

Rita and Anna M Wright

AuthorHouse™ UK
1663 Liberty Drive
Bloomington, IN 47403 USA
www.authorhouse.co.uk
UK TFN: 0800 0148641 (Toll Free inside the UK)
UK Local: 02036 956322 (+44 20 3695 6322 from outside the UK)

This book is printed on acid-free paper.

ISBN: 978-1-6655-9283-3 (sc)
ISBN: 978-1-6655-9282-6 (e)

Print information available on the last page.

Published by AuthorHouse 01/07/2022

authorHOUSE

Under the Fig Tree

ABOUT THE AUTHORS

Rita Wright is a psychodynamic counsellor with more than three decades of experience. An addiction specialist and CBT practitioner, she has also written a novel, a self-help book, and ghosted several biographies. She is now retired but is in the process of setting up 'The Anna M Wright Art' foundation and several exhibitions to raise funds to help people who are in danger of taking their own lives, or have lost loved ones to this terrible loss of loved ones.

Anna M Wright was a student at *The Surrey Institute of Art and Design* where she attained a First Class Honours Diploma in fashion and illustration. Although she was plagued with mental health issues throughout her life, there were many years of happiness and success. She illustrated fashion designs 'around the world' with BBC World Services and travelled to Delhi to design several collections for some of the most famous global high-street outlets. In 2014 she moved to Paris – a place she felt she 'belonged', and was welcomed into the Parisian art scene where she exhibited work entitled 'sono le sei meno un quarto' with *Dessin Partage*. Anna's solo exhibition was shelved due to the 2016 terrorist attacks in Paris – an event of aggression that saw her fall back into a dark depression and untimely death at the age of 37 years.

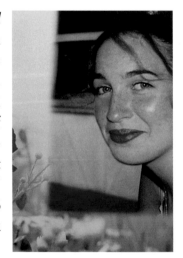

Foreword

The day I received a request from Rita Wright asking if I would consider being a patron for her late daughter Anna's foundation, I was staring up at a beautiful piece of mosaic art my dear grandson Keita had made for me before his tragic death in 2001.

I answered immediately. Hope filled my mind. For two decades, I had searched for an organisation that could help me and my family through the minefield of emotions that crash your world to pieces when suicide enters and changes everything.

My life has been filled with drama and trauma, but I've always been stoic and determined. My philosophy has always been 'seize the day'. I may be older than the young trailblazer I used to be, but I was sharp enough to respond to Rita's request without reservation. I would be a patron of this new charity with the aim of 'being there' in any way I could to help others suffering the devastating effects of losing a loved one through suicide. Loss and grief are part and parcel of life when someone dies, but there is a different slant on a death when a family member kills themselves. Blame and stigma enter the picture. Shame colours grief, and you are left with a million questions. What did I miss? What more could I have done?

When I met with Rita Wright and we shared stories of love and loss, I felt tremendous relief that, with this book and her daughter's foundation, we might be able to reach out to others on a meaningful level that could bring about a sense of relief and connection. Being alone with grief is torturous, and right now, more than at any other time, too many people are suffering in isolation.

Suicide is an angry scream and sometimes a rage at the world. Families are left reeling and in terrible shock. They need to communicate and identify with others whose worlds have changed in a heartbeat.

Keita was detained by the police and put into a holding cell because there was no place available in the mental health services. The circumstances surrounding his suicide led to many court hearings and eventual success, as my daughter Cleo and I managed to get the law about neglect changed in Europe. Back then, I used all my energy to fight for justice. The frustration that sapped the energy from me also fed me and spurred me on with renewed energy. There will always be something to fight for.

Today I sit and gaze at Keita's art and Anna Wright's photograph, and like to imagine they are together. I also wonder whether it was them who threw Rita and I onto the same path. I anticipate that this new charity will do great things. Its aims and goals embrace the creative arts and encourage communication and connection.

This year we celebrate fifty years since the refuges for domestic violence were founded. There is much to celebrate but also much left to do. Let's hope all mental health facilities will make great strides forward over the next half century and that those struggling in this difficult world can find a way to stay alive.

—Erin Pizzey
**Author & Founder of the first safe
refuges from domestic violence**

Time to go -- One last coffee.

I step out of the undertakers into the cool air. I'm holding a large box which contains the remains of my daughter, Anna, and I feel numb. It is as if I have been frozen in time. If she was still alive we would go to the coffee machine close to the railway station before we drove off to go to the shops or Richmond Park. I opened the passenger door and gently placed her ashes in the passenger seat where she used to sit. I turn the key and George Michael sings 'Jesus to a child'. I'm in tears again. After wiping my eyes I decide to drive to Costa coffee. We used to go there all the time, but this was the first time I'd ventured inside since her death . I've even had to lower my eyes and hurry past, pretending it's not there. Now, as I walk through the glass doors the strong aroma of coffee hits my senses . My ears are offended by the noise of people chatting happily as we once did, and the clattering of cups and saucers almost sends me running back to the carpark and the safety of my car. Yet I keep going. I press on and order just one flat white coffee before taking a high stool at the window. With Anna on the table top beside me I look out of the window unseeing. I don't look behind me at the tables set for two . If I dared to think about happy times when we would share a sandwich and natter away without a care in the world, I would collapse. Instead I gaze out at the people rushing in and out of the shopping centre. I am living the loneliest moment of my life.

I try to tell myself that Anna is somewhere peaceful now, no longer anxious and afraid; but I'm not sure I can believe the notion . Has she really gone forever? Could it be possible she is never coming back? I drain my coffee cup, pick my Anna up, and step down from the stool. I pull the glass door open. With tears streaming down my face, I made for the car park. How can I shop for clothes when I can't buy her a jumper or some face cream for sensitive skin? How can I watch mothers and daughters, arm in arm, as we used to be?

I start up the engine and take a deep breath, 'It's time to go Anna – maybe we will have a coffee together again when we meet in the parallel universe you always believed in'.

Contents

1.

Death, Funeral, Wake, and Inquest—Summer 2019

Death

I'm staring at the telephone screen.

It's telling me my eldest son, Andy, is calling.

I answer, and his voice is low, telling me my ex-husband's girlfriend is trying to get through to me. It's urgent.

My daughter, Anna, is staying down at their holiday home for the summer.

She would be the only reason for this call.

Now the phone is ringing again.

I'm standing, looking out of my bedroom window at the trees, when she tells me, 'Anna has hung herself.'

My world spins on its axis, and I fall to the floor.

The image of her hanging fills my head.

I retch.

I can't be alone with this.

I make it to my neighbour's, but by the time she opens the door, I have fallen to the ground.

I can't breathe.

My neighbour says, 'What on earth … ' and then stops.

I can't get the words out—they cannot be true.

I can't say her name. I can't use the past tense.

By the time an ashen Andy arrives, I am catatonic with electric currents shocking me into spasms of 'being here—not being here.'

I'm in his car.

I'm in his garden with whiskey, with his wife and their dogs.

Silence.

No yapping or barking.

The dogs have been told.

My view of my future is cut off.

I am paralysed.

Andy says, 'Billy has been told.'

Anna's little bro, as she called him.

'Where is he?'

'I don't know. He was in a car on the M25 with a work colleague. He yelled for the driver to stop and then ran across a field.'

My heart is breaking all over again.

They were so close.

All our hearts are breaking.

'Who found her?'

Her dad found her. She had been dead for two days. She was cold.

Tiny and cold and alone.

Questions swirl in my foggy brain. I think to myself, *I have a dead child. My daughter is dead. I am condemned to a new title, 'the mother of a young girl who took her life.'*

And the guilt begins right there and then.

The precious life I gave to this little girl is no longer. She checked out.

From now on, I will be a member of a brutal club called the 'Dead Mothers Society.'

There is no way out.

The centre of my universe and life as I have known it died with Anna.

I'm puffing on a cigarette and drinking whisky.

Funny what goes through your mind.

My thoughts flash back to a long past memory where my mother is standing by my grandmother's fireplace, smoking one of my grandad's favourite cigarettes and sobbing. My nan screams for her husband, who left for work a seemingly healthy fifty-something and dropped dead whilst sitting on a bench with his flask of tea.

I was ten at the time, I remember, and their grief terrified me. The wailing was like nothing I had experienced before—it seemed to rise from some deep place inside them and chilled me to the bone.

My mum wasn't a smoker, and neither am I, but here I am, sitting in my son's garden, remembering my mum's shock on hearing her dad would never be coming home. And now Anna will never be coming home again, I feel a brutal punch in my gut similar to what she must've felt that day in 1962. I am grateful my parents aren't alive to witness this latest shocking death.

As we sit together in the garden, I can hear Andy saying how well Anna had looked when he'd seen her just before her birthday on the sixth of August. I nod in dumb agreement.

* * *

We ate pasta at her birthday lunch that day in Portsmouth, and I commented on how the summer sun had given her a glow. She laughed and said how she had been swimming in the sea with her dad's Border collie, Paddy. She said it was like being with our dog, Robbie, with whom she had grown up.

'I think I've been regressing a bit,' she said, laughing. 'I've been thinking about how happy we all were when we lived close to Box Hill in Surrey—when we

were all together and loads of people used to visit us. You used to joke about throwing another carrot in the spaghetti Bolognese so we could make it go round.'

I remembered. I will always remember and be grateful for these ghostly memories that now haunt me during dark nights. I have cried "I remember …" a million times to both myself and others, and I guess it will always be that way until I die.

I'm so grateful for the memories, and as time passes, I remember more and more of the good times—the loud laughter and infectious giggles *do* squeeze through the black lines of grief.

'You were always wearing your gym leotard with your badges and forever standing on your head,' I said to my daughter, smiling as we ordered food.

'But I couldn't do a cartwheel,' she said with a laugh, 'and Billy tried to copy everything I did. He looked so comical.'

We reminisced about games they'd loved to play on a summer's day. Anna loved collecting snails. Once she'd had enough, they would stand them in line, and off they would race! Billy would get bored with this tame game and instead loved to ride his bike around the garden followed by Robbie the dog—that devoted Border collie who had been a working dog on a farm until his owner had died and we'd rescued him. He'd been a loyal and faithful dog. If any of us ever cried, he would put his paws on the sofa next to us and lick the tears from our faces.

When I pointed this out, Anna reminded me of the time her dad, Martin, took Billy out into the lane outside our house on his new bike. Billy had gone racing ahead without checking the brakes first.

'He nearly flew down the hill and onto the Mickleham bends. If it hadn't been for two nurses standing at the bottom, he would have been on the main road. They grabbed him off the bike, and he was really lucky just to have scrapes and cuts.'

It was true. He was a lucky boy.

'I'd rather not remember stuff like that,' I said with a grimace. 'I like to be reminded of the time your dad and I took you both to Disneyland in Florida on Christmas Day. You both came downstairs expecting lots of Christmas presents to be under the tree, but instead, two luggage labels were hanging on it with Minnie's and Mickey's faces smiling down at you. Three hours later we were boarding the plane. And then Billy saw his best friend, Jaimie, and his family. We'd secretly planned everything. The expressions of surprise on the boys' faces were just great. And they played all the way to the USA. But you, Anna, were content to just draw and read.'

Billy had always been full of energy, the comedian of the family. Everyone loved being in his company, and it's no different now—he still makes everyone laugh with his dry, ironic humour. But he is also deep, and I think he still tends to suffer in silence.

Now, as we sat in the restaurant, we recalled this and other funny stories about our family. It was far too breezy to sit outside, so we'd chosen a little Italian restaurant. I said, 'All is calm on the eating front.' There was no twenty-minute wait whilst she checked all the calories; she went straight in with a seafood pasta. She was OK with me having a glass of wine, and she had a lite beer. I was thrilled at the ease of our lunch date. Anna seemed in a great place, and there was no tension whatsoever. Afterwards, we went to the outlet stores, and I bought her a warm, blue jumper and some thermal vests for myself.

When we returned to the railway station, she said she would jump on my London-bound train and get off at Fareham to change for Hayling Island. We sat opposite each other for approximately ten minutes, chatting and laughing.

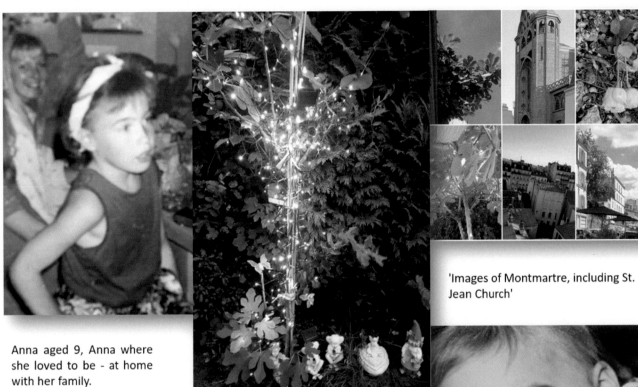

Anna aged 9, Anna where she loved to be - at home with her family.

Baby Fig Tree planted in garden in Wimbledon, London

'Images of Montmartre, including St. Jean Church'

Anna, Phaedra, and Lucia on Anna's first trip to Paris with University just before a thief attempted to steal, amongst other things, her red Chanel lipstick

'Baby Anna'

What on earth did I miss?

Her birthday has always been so special. Even if we'd been living in different countries, we would meet up for her birthday. I'd flown to Paris one year, and she had spent August with me in Spain. When she was little, I had quickly learned she wasn't a fan of noisy get-togethers but much preferred little tea parties with family and friends. We visited our favourite haunts, such as London's Southbank and Borough Market, or took boat trips down the River Thames to Richmond and Hampton Court. We knew each other so well. There were no subjects we hadn't discussed. Our opinions differed a lot on many things, but it was fair to say we each respected our differences.

I was waiting for my inheritance from my late parents' estate. It had taken ages in probate, and the whole experience with lawyers had been stressful. Dealing with legal matters after death is, as we all know, a nightmare.

I mentioned it would all be over soon and life would get easier financially, and she clammed up. I took the hint and changed the subject.

I suggested we go to France to see her boyfriend, Manu, and asked if maybe there was a chance of a reconciliation. Her expression darkened, and she changed the subject.

I changed tack and focused on my new phone, saying I was still having trouble learning how to use a smartphone. She knew I was useless with anything technical, and once again she managed a laugh, but it wasn't real. I almost said, 'Come back to mine tonight,' but I didn't. I just kept saying, 'It will all be over soon.'

At Fareham, we stood and hugged. She turned to leave but looked back with tears in her eyes. Her expression tugged at my heart. Poor Anna didn't know where she belonged.

She left the train, waved through the window, and disappeared. I never saw her again.

Funeral

The shock that attacks your mind and body when your child takes their own life is indescribable. It is so unnatural that I'm certain whoever created us never even thought such an anomaly could happen and therefore gave us no defences.

During the two weeks leading up to Anna's funeral, I was one ball of adrenaline—organising, arranging, and making choices no parent should have to make. I was just like any other person faced with burying their loved one. Thank goodness we are kept busy. Collecting the death certificate is cruel and choosing flowers is impossible. What do you write on the little card you attach to the flowers? I don't remember what I wrote. I don't want to remember that poignant last goodbye note. We had written each other so many cards and letters when she was alive, and these would be the messages I would hold onto until we met again in another universe.

As the funeral procession stopped midway down the road leading to the chapel and we all sat in the sombre black cars, I noticed a slight young woman tottering on black high heels and wearing a beautiful faux fur coat walking towards the car carrying Anna's coffin. Her raven hair and bright-red lipstick made me gasp—as it did Manu, who was holding my hand.

The woman was Anna's double. She stopped next to the waiting hearse, lit a cigarette, and inhaled one almighty drag into her lungs. It was Phaedra! I stepped from my car and walked up to her. Hardly able to focus for tears, I hugged this beautiful, quirky young woman.

'I'm just having my last fag with my mucker,' she said, cocking her head towards the coffin, and then she proceeded to have a private conversation with Anna. It was a marvellous moment. It was also a brutal moment.

Choosing music for the service proved to be a headache, as Anna loved music and had many favourite songs across many genres and eras. Patti Smith's *'These Are the Words'*—from the soundtrack to the film *Pope Francis: A Man of His Word*—was played as the central hymn. Patti was a catholic, and ever since we'd had my dad blessed by a priest on his deathbed, Anna's closeness to God and anything spiritual had grown.

Anna loved both Patti Smith's music and her philosophy. When Anna had lived in Montmartre, she'd read *The New York Times* every Saturday whilst sipping strong coffee accompanied with croissants. Manu would be next to her, poring over his French papers and magazines. Patti Smith had often featured in the American news, and what she had to say had inspired Anna. There was no doubt Anna's horizons had expanded during those blissful years. Billy had told me how much Anna had loved listening to the pianist *Ludovico Einaudi* whilst drawing or creating jewellery. He'd chosen a track entitled 'The Path of the Fossils' from one of *Einaudi*'s albums to accompany her coffin into the chapel. It was a perfect choice. It might've raised a smile on another day. The final track was a conundrum for me, as there were so many artists she'd adored, from the *Guns N' Roses* she'd loved in her 'gothic' phase at age 7 (in particular the song '*Sweet Child of Mine*') through her *Kylie* and *Madonna* eras to her *Dusty Springfield* phase. It came down to *Madonna*'s '*Take a Bow*' and *Dusty*'s '*Son of a Preacher Man*'. It occurred to me that whichever one chose, I would always wonder if she'd rather have had the other one. In the end I'd gone with *Madonna*.

I managed to get through the eulogy, but my memory is a blur. I know I got through without tears, and I know I didn't falter in my speech. I was speaking for my daughter, and doing her justice was my only concern. Friends read poems and paid tribute to Anna in front of crowds of tearful friends and family. The sister of Anna and Billy's faithful au pair, Anjii, read a poem in her absence. The service, which the vicar timed carefully, was interrupted just after Patti Smith's fabulous words by none other than Phaedra.

'I'm sorry … I'm sorry … but I just have to say a few words about this wonderful friend, who I am going to miss so much.'

I can't remember what she said; I don't think I listened. I just watched on in delight, as did the rest of the congregation.

I fell apart when Madonna sang, 'Take a bow. The show is over.' I just wanted to crawl into the coffin and go with my girl. But the show really was over. Once outside the chapel, where people were congregating across the grass and the rose bushes filled the air with a sweet scent, Martin and I released two white doves in honour of our daughter's soul, which was now soaring high to the heavens.

I wanted to be happy that she was at peace, but I selfishly just wanted this all to be a nightmare I would wake from and find she was still alive.

The venue for the wake was carefully thought out, as Anna would've hated for us to celebrate her life in a pub. My godson, Daniel, who is so bright and never lets the grass grow under his feet, went online and found the perfect setting within minutes. He wrote it down on a scrap of paper, which I have kept.

He had stumbled across an advert for a beautiful golf clubhouse in the middle of the peaceful Home Park, a beautiful space filled with trees and ponds with deer running wild. The road ran from Kingston Bridge to Hampton Court Palace. The clubhouse was light and bright with huge windows and a sweeping staircase up to the main room, where a typical afternoon tea and little posies of colourful flowers had been spread across pristine tablecloths.

Everyone was there, from childhood friends to university colleagues and tutors to friends she had made in both London and Paris. I spoke to everyone but wasn't really living in the present moment. That wasn't *my* daughter's face smiling down on us from the screen on the wall. This wasn't *my* daughter everyone was talking about as they spoke of the lovely girl she *had been*.

Had been … was … What?

More and more images flashed past my unseeing eyes—Anna as a baby, a toddler with crazy hair, a cute toddler by the seaside, a school photo, a passing out day at Guildford Cathedral in full black gown and graduation mortar cap. I saw my dad hugging her and the two of them smiling into the camera as other relatives stood in the background at what was clearly a happy family event.

She was so alive—how could she possibly be dead? It didn't make any sense. It was surreal, and I absorbed nothing. Instead, my mind kept asking, *Where are you?*

I asked myself this question for months. I still ask it. I always will.

The late-summer day was drawing to a close. The park was resplendent, and there was a warm breeze in the air. Those of us still present had moved out of the bright rooms and their sparkling chandeliers to the tables and chairs on the patio. Manu looked lost and weary; everyone was weary with low energy. Some of Anna's friends were crying, and they were setting others off all over again. I viewed these lovely people through a veil of overwhelming grief and felt so very proud of my late daughter. *I know you can see this, Annabella,* I thought. *I know you are with us here in this beautiful place.*

I saw the requested cars winding up the road towards the clubhouse, which heralded the end of the wake and this most painful of days. The funeral of that little bundle I brought into this world was done and dusted. Manu and I climbed into the back of one of the cars, and as it pulled away, Manu whispered, 'Anna's song is on the radio.' It was indeed. The local Radio Jackie was playing Dusty Springfield singing 'Son of a Preacher Man'.

That night, lying awake with a sodden pillow, I put my hand behind my back, searching for her little fingers to entwine with mine. We'd used to do this when she stayed with me. I missed those little hands.

Manu returned to Brittany the following day with a head full of guilt and a heavy heart. His reason for feeling like he was to blame for Anna taking her life was that he had spoken to her on the phone the morning before she died and thought he must have said something to upset her. The guilt everyone feels after a loved one commits suicide is enormous.

Inquest

I had never been to an inquest, and I didn't relish the thought that I would have to go. In fact, I was terrified. The fear of the unknown mingled with the terror of listening to the details of her death day. The thought of hearing about my daughter's last moments alive and how she died whilst I sat in an alien environment made me physically sick.

It was late in 2019 that we were given the date of 2 March 2020; it would be held in the afternoon

in Portsmouth, where I had last seen Anna on her birthday. I dreaded being in the town where we'd last said goodbye and vowed that after this was over, I would never set foot there again.

I immediately became agitated, and my nerves were stretched as tight as a drum. To stop me from climbing the walls, I had to get out in the fresh air and walk in spaces new to me—spaces that didn't bring memories of Anna flooding back. I also visited old haunts from my teenage years, and although it was winter, I wrapped up warm and walked along different paths beside the River Thames. I took the pathway along the river in Richmond, down through Ham, and across the common towards Richmond Park. I had walked this route a hundred times in the seventies with my first son, Andy. We'd lived in Twickenham at that time with his dad, Michael, who had tragically died in 1988. We had no money to speak of, but we were happy. Walking along the river in Kingston was a favourite, as it was so lively with all the riverside cafes and restaurants. These were what I referred to as 'white spaces'—devoid of both good and bad memories—that allowed me to simply focus on being in the present moment.

I filled January in a similar vein. Then in February, I took a trip to Gran Canaria, and the week I spent there proved to be the beginning of some very dark days. Even the sun decided not to shine. There were very few holidaymakers. It wasn't the usual noisy island I had experienced before, which had been full of life and laughter. The location was echoing my sombre mood.

A sandstorm blew across from the Sahara Desert, and the air turned red. The wind howled through the corridors of the hotel, and the atmosphere was suffocating. We were ordered to stay in the hotel—preferably in our rooms—and wait for an update. The update we eventually got was even scarier.

'There has been a case of Covid-19 detected in a Tenerife hotel, and all guests have been put into quarantine.'

I sat on my bed looking out at the red mist that now enveloped the hotel, and it was then that I spotted a bird sitting under the balcony table. That one single bird stayed there all day, and in my fragile state of mind, I decided it was Anna and that she had come to keep me company. I think in that moment, far away from home and alone, I realised my days of travelling across Europe as a singleton were over. I had changed. My confidence had taken a nosedive, and my

ability to be comfortable in my own company had dissolved. *I* was dissolving, and as I flew back to the UK a nervous wreck about the impending pandemic and the imminent inquest, I felt as if I were completely disintegrating.

The following week, my close cousin Sue, who is only a few years younger than me and more like a sister, drove us down to Portsmouth. We were quiet, which was very unusual for us, as we usually chatted ten to the dozen. We had both spent an enormous amount of time at our maternal grandparents' house with our other cousins. Sue had three children and her eldest daughter Katie was my godchild, as were Daniel and Erin, the children of her youngest, Laura. Laura had been born just nine months after Anna. We were all very close, and Anna's death had hit us all like a sledgehammer.

The other people attending the inquest were Anna's father, Martin, and his long-term girlfriend, Claire. The policeman who was at the scene had come to give evidence, and two female journalists from *The Portsmouth News* joined the small gathering. Finally, the judge entered the cold, sparse courtroom. In contrast to all of us, he displayed an air of calmness, which was a blessing.

I shook all the way through the proceedings. My whole body was rigid with nerves, and my jaw was so tense that a migraine began to flash across my eyes. I was terrified. When Anna's dad told the grim story of finding Anna and how cold she was, how they had to cut her down and lay her on a bed, and how she had been dead and alone for two days, I too felt frozen to the bone.

I didn't have to give evidence, but when asked if I had any questions, I said, 'I do.'

Ever since I'd heard the news of her death, I had been ruminating about whether she had numbed herself with tranquilisers and/or alcohol. I so wanted her to have been cushioned from what she was doing to herself. But the answer was a resounding no; there had been no chemicals in her body.

An involuntary whimpering sound escaped from somewhere deep inside me. I hadn't really wanted to know, but it was so important to me to get a feel for what was running through her mind in those final moments. Had she been frantic or calm? I would never know. It would forever

be one of those awful unanswered questions that haunt you after the sun goes down. But I was also certain that Anna would have wanted to give us a clear message that could leave no doubt in our minds that she meant business and that she didn't need to be stoned or drunk to carry out her mission. I cried and cried for my beautiful girl.

Then the judge summed up, 'Anna took her life, and I believe she meant to do so.'

One simple sentence literally stopped my heart beating, and it felt as if all the air had been sucked out of me. The policeman was sombre and sad. As we walked away from the courtroom, he told us that this job of going out to scenes of suicide was becoming all too familiar and more and more young people were taking their lives.

The journalists wanted to run a story on Anna's life, and they were eager to run an online gallery of some of her art. They also said they wanted to know when Anna's foundation was going to be up and running, as they would like to write another article to raise funds. At that moment, it felt as if I would never have the energy to get out of bed again, let alone run a charity. I was doing what I always did—thinking I had to decide everything right then. It took me a year to realise it had to be one thing at a time: book first, then set up the foundation, and finally arrange two art exhibitions—one in London and one in Paris. It seemed the most sensible thing to do, especially now that the coronavirus had struck.

On the drive back through Hampshire, the radio news told us a case of Covid-19 had been diagnosed in the very town we had just driven through. As we had just stopped for petrol and coffee, we looked at each other, both of us wondering what the hell was coming next. We jumped back in the car and flew down the A3 heading for the Cobham Sainsbury's, where we stocked up on essentials—well, any that were left, as the hoarders had already flapped their way around the superstore. The loo rolls and pasta had already been snapped up by panicked shoppers, and we were getting our first taste of the impending doom of lockdown.

Thank goodness we were ignorant of the fact that this new way of life would impact us so much and for so long. I remembered Anna's prophetic words, 'The world is on its last legs.'

Two weeks later, we were all confined to our homes, washing our hands whilst singing 'Happy

Birthday to You' and covering our faces with hot and itchy masks when we ventured out into deserted streets to exercise and precariously enter the local corner shop for bread and milk.

I was about to find out that grieving my daughter alone in my compact Wimbledon apartment was beyond awful. She was everywhere. I would reach out for her in the night to hold her little hand only to find the bed empty. I would wake from a nightmare, and she wouldn't be there to soothe me and make a cuppa. I missed her snoring, which used to get on my nerves, and I even wished she were there telling me how bad her sweats were and how we needed to change the sheets in the middle of the night. I longed to hear her scornful cry of 'Turn that bloody Steve Allen off the radio! No wonder you don't sleep properly!' And where were the low, muffled murmurs in my ear as she wandered through her dream world?

When I was indoors, I was desperate to get outside, but the minute I stepped onto the nearby common, all I could see was Anna. I saw her sitting on a log rolling a cigarette with her little tote bag, which held her reading book.

The benches we used to sit on with a coffee were now tied up like criminals with long streamers usually saved for crime scenes. Big, official notices were affixed to them telling us in no uncertain times to 'just keep walking'. Our bench looked so lonely—so out of bounds. Our resident heron had disappeared from the pond, and even the ducks looked wretched. One day, I ventured further through the trees along the side of the golf course and down to a little café called The Windmill, where we often used to drink tea and eat home-made cake, but I missed her too much to repeat the journey. The longing inside for her was indescribable. It was an ache. It was a sickening ache that never went away.

During the first national lockdown, I was quietly pleased that I was forced to stay indoors. I went out daily for an hour to pop over to the local co-op and breathe some fresh air in as I walked through a deserted Wimbledon Village. I gave these beauty spots a wide berth as much as possible as they made me cry. The gym was closed, meaning I couldn't swim, as was the library, which was another of my favourite haunts. I had to be content with running up and down the three flights of stairs to my apartment, which meant more time alone.

Even sitting on one of the benches in our communal garden was too much to bear, as we used to sit here with our coffee while she puffed on a roll-up. Now, from my upstairs window, I would look down and remember her sitting outside with a book. She was simply everywhere.

After a few months, I asked Andy to plant a fig tree opposite my window, which I draped in solar lights. I must say, I did get such pleasure from watching the lights come on at night. But on angry days, I was known to scream at the top of my voice, 'Where are you, Anna? How could you just check out and leave me? All I've got now is a bloody tree!'

If she were there, she would have laughed out loud at that, and we would have rolled around in a play fight. But she wasn't there.

When I got stronger, I decided, I would wander further into Wimbledon Common and find the tree where Manu had carved their initials, but for then I had to be content just knowing they were there.

2

Paris, November 2019

It was now three months since Anna had taken her life, and I was standing outside Guard de Nord railway station in Paris waiting for Anna's boyfriend, Manu, to arrive from Brittany and for Billy to fly in from Poland. It was late afternoon and chilly. I saw Manu straight away, his long legs striding towards me. He wore a faint smile on his face, but he was tense—he hadn't thought he would be able to visit Paris, his one-time home with Anna, but he had fought his fear and bravely returned for this important rendezvous.

I hadn't seen him since the funeral in Surrey, and I saw he was still grieving badly. His six-foot frame was skinny, and his dark mop of hair was now long and unruly. We embraced. We didn't know what to say to each other. We were still in shock.

Billy arrived, and the boys greeted each other as if they had been friends forever, whereas they had only, in reality, met a handful of times. I guessed all this serious grief had locked in a lifetime of friendship. This was healthy for both of them, and my heart had a brief respite from pain as I watched on with motherly pride. Manu was my French son—nothing on that score had changed, and it never would. Anna's soulmate could never be erased from my heart.

We turned right and walked up towards the Basilique du Sacré-Cœur, eager to make it there before the cold evening set in and the light dimmed. It was quite some climb, and as we reached the concourse beneath Sacré-Cœur, I saw Billy's eyes grow wide at the sight of the rooftops of

Paris that stretched far and wide. The Eiffel Tower was away in the distance, and the sky was steadily darkening as the sun went down. He snapped away with his camera, and I asked him to take one of Anna's favourite *carrousel*. Then he turned his attention to the mighty Sacré-Cœur and stared up in awe.

We all walked inside in silence. Once inside the church, I lit one of the red candles—candles we had once lit together. I raised my eyes to the beautiful stained-glass windows in prayer and asked God to keep her safe. In my hand, I grasped a small tin that had once belonged to Anna and that now contained a small handful of her ashes. I gripped it tightly and spoke to her.

'You can't leave here completely. I know how much you belonged here.'

It was enormously painful being there without Anna. I felt as if I were invading her own personal space, and it was quite disturbing. Why should I be able to walk the streets of Montmartre without her?

I was to meet up with some of Anna's French friends whilst there. Their phone numbers were written in tiny handwriting in her phone book. It had felt so intrusive looking for the numbers, but it was necessary to rummage through certain personal items. I was still wondering if she had hidden a suicide note anywhere. There was so much art and paperwork and poetry in my bedroom . She was everywhere— in my head, my heart, my very existence seemed to belong to my daughter who had left us. People say our loved ones never really leave us, and for most of the time I believe this to be true. But there are times of extreme pain and anger when I seem to lose faith, and I soon learned they were the worst times. Keeping faith is essential if you are to survive a horrendous loss.

We were set to have lunch with Anna's Parisian psychoanalyst, Sylvette, at some point. I was eager but afraid to meet her. She had been so dear to Anna, and I knew Sylvette was devastated by the sudden death of her English rose.

Our other destination was Montmartre Cemetery, where Anna and I had used to stroll and picnic on fine days. That's where I was taking the little tin of ashes. I needed to find a fig tree.

'Montmartre - A little piece of Heaven'

NOBODY IS TO BLAME.

I DREAM THE SAME SCENE

NIGHT & DAY INTO NIGHT AGAIN

NO-RIDDLE NOR REASON
I SANK INTERNALLY SHAMED

SHE TRIES AGAIN & INTO AGAIN

ADVANCING DESCENDING ASCENT
I FEEL THE GAGE
TEMPERATURE TROLL. HAIR WIRED

AN ARRIVAL OF THE FAMILIAR CALL
TO FRO LOVES' YELLOW SAW
FISHING CHEMICAL MORES.

ESCAPE IS A FAILING PLAZA
CRIES ARE ONLY USEFUL ALONE
& CONNECTING VIA A WINK. THE,

STRANGER. QUIET MONDAY "EERIE" YES.
SAME DAY. JUNE 15 2019 "CREEPY."

STRANGE FATE.

EYES (& OTHER
GESTURES)

Little letter mum found months after Anna had taken her life. She had dated it June 15th 2019 - she had written it 7 weeks before she died.

THE SELF- IDENTITY; DISPLACEMENT.
HUMAN MEMORY &
THE OUTSIDE PORTRAYED IN FILM
SEARCHING THROUGH ART
CHANGING POSITIONS
THE FIVE SENSES
& FOLLOWING MIND PLACE
TO PLACE.
HOME & HOMES FROM HOMES
SMALL ANXIETIES
& POEM LINES SHAPED, SELF ABSORBS,
TEMPORARILY.
COLOURING PICTORIAL IMAGES FLIP FRONTAL-
REM DREAMING
ANY HOUR EITHER MORNING OR AFTERNOON
SPLITTING THE DAY INTO PARTS
DRYING THE DREAM PHYSIQUE
SPONGING MENTAL
EMPATHY & COMPASSION
THE OUTSIDE FROM IN SELF
FAMILY, RELATIONSHIPS, LOST ONES. PAIN
& A WORLD OF SEASONS CONFUSED. FEAR
BURN CHILLS
THE STEM FROM TREE'S
OCEAN ROOTS...

LEARNING HOW TO DIVE

SWIMMING CULTURES. MAY 28 2019

'Learning how to dive' written three months before Anna died.

YOU HAVE TO BOOK A PLANE FIRST

BUT IMAGINE.

Imagine.

I had booked three single rooms in a hotel on the edge of Montmartre. I had never stayed there before, but it was close to all the places I wanted to show Billy. When the taxi drew up outside, Manu gasped, 'Anna has stayed here before.'

I narrowed my eyes and looked at him in puzzlement.

'She was having anxiety and panic attacks after the Paris terrorist bombings and wanted to be alone to think about her future and whether she wanted to move out of the city. I am sure this is where she stayed.'

I turned to the receptionist who was checking us into three rooms, one on the third floor and two on the fourth. 'Do your records show whether Anna Wright has ever stayed here?'

He scrolled through the guest lists

'Yes, she stayed here in 2015. She stayed in room 405.'

Manu was holding the key to the very same room.

I didn't know whether to be alarmed or happy. To be honest, it was a bit spooky. Anna had believed in the existence of a parallel universe and was very spiritual. I thought I believed too, but to be honest, I didn't want to think about life-after-death issues. It was far too soon after her death to go there! On the other hand, I certainly did not believe in coincidences.

Once in my room, I allowed myself to feel close to her and had a tearful little chat. I threw the shutters open to breathe in the cool night air but had to close them again, as the sight of Paris by night broke my heart all over again.

I switched my soul onto autopilot and went downstairs to meet the boys. Manu shook his head as he looked down at his door key, knowing Anna had once held it.

I gave him a hug and said, 'Come on. We need to eat.'

We made our way to the colourful buzz of the famous square, *Place du* Tertre, where artists gather to paint and sell their art. It is always filled with tourists eager to experience the bohemian atmosphere. This was all new to Billy, and I enjoyed watching his ever-changing expressions as he watched Parisian life in full swing. He had never visited Paris, as he had been travelling across America for most of the time Anna called Montmartre home. Their meetings had been back in London, usually for celebrations but more recently for funerals. Anna's other brother, Andy, had only been to Paris once—for a football match between Arsenal and Paris Saint-Germain. The only sights he had visited outside the stadium were the Champs-Élysées and the Eiffel Tower, and he wasn't enamoured. None of us were able to coax him to Paris.

As we sat at a little table outside a restaurant in the square, I began to realise how much it meant to me that Billy 'got' Paris and saw and felt what his sister had loved so much about the atmosphere. He ordered a platter of cheese and meat and some smooth red wine for us all to share. I studied this sensitive boy's glistening eyes as he watched the artists paint pictures and draw portraits in the bustling square. He saw the tourists handing over euros for works of art or snuggled into their winter scarves as they sat under outdoor heaters whilst holding steaming cups of coffee and smoking French cigarettes. The man who'd used to sit under a tree in the tiny square close to Anna's little apartment next to what used to be Picasso's home, was there playing his accordion. My daughter's absence was palpable.

She'd adored this place. I just couldn't believe she was not there with us.

'Do you like it here, Billy?'

'What is there not to like?'

He and Manu were thinking the same as me—Where is she?

Cemetery

Sunday morning, the day dawned bright, and the skies were blue. We took a taxi to Montmartre Cemetery, and as we walked across to the florist along the stunning, tree-lined avenue Rachel, I realised all I could hear was birdsong. I wasn't crying. I had zoned out of reality.

As I passed through the large wrought-iron gates to Anna's favourite cemetery (there were several in Paris), I was aware that I was unsteady and my head felt like cotton wool. It was just as if I were walking on air, disconnected from the real world. I'd walked through this impressive cemetery many times with Anna, and I just couldn't get to grips with being there holding a tin of her ashes instead of walking alongside her as she pointed to all the amazing statues and gravestones. She wasn't there laughing about picking an apple from one of the rows of fruit trees lining the pathway through the large, sprawling space where many famous artists, doctors, and statesmen had been laid to rest.

'It is surreal,' I managed to whisper.

'It is sad. It is not true that I will never see my Anna again,' croaked Manu through his tears.

It was.

The November breeze was light—almost warm—as I led the way. I was going to the little area where she loved to picnic and quietly read her book. Up the steps, I led the men. Manu reached up and plucked a red apple from a tree, and Billy grinned. He was getting to know Manu better, and the bond was clear to see. Benches dotted the pathway, waiting to relieve tired feet of weary visitors. The flagstones were uneven—ready to trip up a half-awake visitor who was still grief stricken after years of mourning a loved one.

A crowd up ahead strained their necks to read the plaques on the huge monuments and statues of famous Parisians buried there. Beautiful carved headstones and angels in prayer all added to the sombre ambiance. I knew immediately which statue was causing the stir. It is the one Anna had loved the most—a life-size statue of Parisian darling Dalida.

There was always a congregation of visitors around the singer's grave, as it was so impressive, and today the sun blazed down on the pristine figure. Egyptian-born actress and starlet Dalida had lived her life entertaining her millions of fans in and around the theatres and clubs in Paris. (I play her music whilst I write this book.) Her life had been colourful but tragic. Her love affairs had always made headline news. She'd ended her life in her tiny flat, not far from where she stood now on public display in all her glory. She would have been happy her fans still loved her and came regularly to place flowers. Anybody of that calibre always fascinated my daughter … and me.

Billy and Manu weren't as intrigued as I was, and it took a while for me to realise they had wandered off along the rugged pathway. They were standing in front of a cracked, whitewashed wall with a crimson flower creeping up it like a slash of bright-red ribbon. It was a wonderful contrast of old, rustic white wall and bright red in colour (like Anna's scarlet Chanel lipstick).

The church bells of St Jean rang out, as if accompanying us on our walk further into the sacred grounds in search of an appropriate burial place for our Anna's heart. Billy had seen something. He pointed to a mature fig tree growing in the sunshine.

'Over there,' he said. 'The sun shines in that corner all day long.'

'Yes,' agreed Manu. 'It's very peaceful and away from heavy footfall.'

I studied the rustic green angel sitting and praying opposite the fully grown fig tree. She seemed to be focused on a small mound of earth next to a small bush. I could see blue sky through the branches and leaves. Looking down, I studied the ground and saw two fallen figs, brown and wrinkled. And it was there, opposite the angel and under the fig tree, that I began to scrape away at the thankfully soft earth. I made a small grave with my hands. There was something very gratifying about getting my hands dirty and nails filthy, and I didn't want to stop. I had to dig deep to ensure she didn't fly away. I needed her to be undisturbed, and I intended to return time and time again to *our* mature fig tree with lots of foliage and fruit.

After mumbling a prayer to God, my mum and dad and grandmothers, and my first husband, I stared unblinking at the earth under my nails. There was something so primitive about that frantic act of clawing earth that gave me satisfaction.

I was not in my right mind.

I doubted I would ever be sane again.

I opened the small tin and emptied a tiny handful of Anna's ashes into the palm of my hand along with a lock of her hair. I then said, 'Goodbye, Anna. You will forever hear the bells of St Jean.'

As I filled in the soil, I could hear birds and see Billy's sad face. I could hear Manu sobbing and *my* heart beating. I left my heart under that fig tree.

The bells of St Jean rang out again—they pealed every fifteen minutes. We'd referred to it as 'our' church, as it was where we had lit candles and prayed for her grandad after we lost him in 2012—the year of her thirtieth birthday.

'I finally belong somewhere,' she had written two years later in her diary when she'd moved to Montmartre. 'It's here by the church, close to Picasso's home and workshop, down the hill from Salvador Dali's museum, and amongst the vintage shops and cafes smelling of strong coffee and sweet tobacco. Finally, I have come home.'

Those had been the most contented years of her adult life. How could I not ensure a part of her would lie forever under that beautiful fig tree in the sun, a stone's throw from place des Abbesses, rue Lepic, place Pigalle, place Blanche, and the red windmill of the Moulin Rouge.

Fig trees have always featured in our lives. There used to be a mature fig tree outside our Spanish apartment. My dad used to pick the ripe fruit for himself and Anna. They would have quiet moments sitting under it chatting, whilst the rest of us would jump in the pool and splash around noisily. Later she became fascinated with the story of Jesus and the fig tree. (The story about the *cursing of the barren fig tree* appears in the bible in *Luke 13:6–9*).

As the story goes, Jesus was very hungry and couldn't believe that all the trees in the fig orchard were destitute of fruit. What he didn't realise was it was the wrong season for fruit. Allegedly, Jesus kicked the tree in disgust, and when his disciples saw the tree later, they wrongly thought it had withered. But it was much more likely to have been a baby budding tree- slow off the mark, just like the one I've now planted for Anna in my back garden.

(Nowadays I sit next to Anna's baby fig tree in my garden eager to see the leaves appear in the hope that one day it will bear fruit. As the sun goes down and the solar lights ping to life on the skinny little tree with tiny green fig buds. I say, 'Hello, Anna,' and smile. I, like Jesus, wait impatiently for fruit).

Yet I also like to think about the few ashes buried under the luscious fig tree in France. It's good to know her soul is there. There are no lights on the fig tree in Paris where her heart lies, but she has all the churches and museums she loves to lighten her spirit, as well as the unique bohemian atmosphere of Montmartre.

Sylvette

Our lunch date with Anna's psychoanalyst was another sad affair with lots of tears. Manu had met Sylvette before, but although I had heard so much about this French woman of similar age to me, this was our first physical meeting. Sylvette was eager to make a point of telling all three of us how much Anna had adored us and how none of us should feel responsible for what had happened. She was as lovely as Anna had said and possessed a quiet demeanour and gentle manner. She cried so much that day, and in her broken English, she explained how fond she had been of Anna and what an amazing talent she'd been. She had travelled to meet with Anna in London several times after Anna moved back to be close to her two grandmothers – which just goes to show how much Sylvette adored her.

It had always been a conundrum for Anna—to be in Paris where her heart was at ease or to be back with her family, who she always felt needed her. If she stayed away too long, she would feel guilty. Anna had carried guilt on her back everywhere she'd gone. Guilt and not feeling good enough had always haunted her, and however happy she'd been, she'd always felt she should

be somewhere else. Anna had been lucky to find Sylvette, who had been a sensible, calming influence on my anxious girl.

At the end of our visit the time came to say goodbye. For a long moment we stood at the entrance to t he Guard du Nord just looking at each other. A devastated Manu told me that he would never again visit Paris. He couldn't be there without Anna, now that his dreams of their marriage and having babies would never be realised. I was really concerned for him. Like me, he was an only child, although unlike me, he didn't have lots of cousins and an extended family. His father had died two years previously, and his mother, with whom he was close, lived in Brittany, his support system was minimal.

We had all invited him to be with us—to perhaps settle in the UK—but Manu was French through and through. Although he had written Paris off, he still had the little cottage by the sea in Brittany where he and Anna had spent many happy times riding bikes and scrumping fruit in the nearby fields. It was a real worry leaving him behind. Saying sad goodbyes at railway stations seemed like a new way of life that I wasn't relishing.

3

Birth—1982

My daughter, Anna, was born sunny side up, which meant her face was looking skyward—straight up at me. The setting was peaceful and serene with none of the yelling dramas one often associated with birth. A nun stood beaming in delight and looked on whilst the midwife, Alice, scooped my little girl up onto my belly. Covered in birth fluids, she slid around until I held her tight and then gazed down in complete awe. Her rosebud mouth was perfectly formed, and her whole body was covered in downy hair. She squinted and blinked against the bright lights in the delivery room in this small private hospital run by nuns in Wimbledon. It was a scene straight out of *Call the Midwife*.

I couldn't believe I had a daughter. My son from my first marriage, Andy, was ten years old, and I had never imagined myself with a little girl. Yet here she was—her little mouth making sucking noises already.

The summer of 1982 was hot and sultry, but the small ward I was sharing with another new mum was cool and airy. The window faced across south London, and as the hospital was high on a hill, I could see straight across the capital's skyline. But with her little cot next to my bed, Anna was the only view I was interested in focusing upon. I fed and changed her and had trouble letting her go when the nurse insisted that my baby had to sleep in the nursery so I could get some rest. My protests fell on deaf ears, and she was wheeled away.

It took ages to get off to sleep. I was exhausted but exhilarated. The nightmare that followed, however, was so horrific that it could be classed as a night terror. I dreamt I was downstairs in a big house and had left my new baby girl in an upstairs bedroom. A fire began to rage on the stairs, and I couldn't get past to save her. It was a pure anxiety nightmare. My desire to keep Anna safe consumed me.

I woke up sweating and panicking, realised where I was, and ran to the nursery, where I found Anna yelling her head off and soaking wet. I picked her up and pulled a blanket around her before bundling her back to my room, where I changed her and then took her into bed with me to feed her. She was clearly ravenous. As I fed her, I promised her I would never leave her again.

The combination of my dream and finding her alone and cold and hungry was to be the beginning of me being a hypervigilant and guilty mother. Some analysts would have said I made her anxious whilst she was at my breast; other child specialists would have said I was too harsh on myself and that I should give myself a break—that as long as my baby was nurtured and loved, she would be fine. When she developed anorexia during her teens, it only served to convince me that everything was my fault. I always felt her unhappiness was my fault.

Looking back, I can see that Anna lived her life in a silent scream. Her needs were vast and complex. Her hair grew wild and blonde, and if I hadn't tended to it before school, she would have gone, in her words, 'looking like I've got a bird's nest on my head'. Half of it was straight and the other half curly. It had a coarse texture and a life of its own.

Fortunately, once her hormones began to flood her body at the age of thirteen, this strange hair became long and thick and healthy and turned from blonde to brunette. But by this time, she had another problem—her teeth.

When her milk teeth failed to fall out, I took her to the dentist, where an X-ray showed that she had two sets of adult teeth. The first set, which was just above her baby teeth, was completely deformed. The second, perfect set was stuck in her upper jaw.

All the dental staff were filled with excitement, as they had only seen this phenomenon in the textbooks, but Anna was angry that she had to have operations and that they all thought it was cool. Anna's expression was easy to read as always—her mouth was set and she scowled—but she said nothing - just seethed inside.

At that time, she was in her last year at a small primary school near where we now lived, high on the North Downs between Leatherhead and Dorking. She was thriving and had already passed her exams for the senior department at the same school when she was admitted to Guy's Hospital in London for an operation to remove her baby teeth and the deformed set just above the gums. I had never experienced a child of mine being given a general anaesthetic, and I found it all slightly overwhelming. You heard stories of people not coming back from operations, and my imagination had always been lively.

After all the offending and deformed teeth had been extracted, the surgeon attached two tiny gold chains to the other set of healthy teeth sitting up in her jaw. These were to act as weights to encourage them down. It was a long and painful procedure, and I was glad they had a small room where I could stay over and be close to her.

Whilst she was in theatre, I anxiously walked the streets of London. I was reminded of the late sixties when I used to work at Scotland Yard. I adored London. It connected with my character so much more than suburbia. Both my grandmothers had been born and raised in south London, and they had passed on their cockney ways to their children and grandchildren. I was glad of the distraction – even if it was only for a few moments. I remembered Sundays hanging out on the embankment with friends, listening to the top of pops charts and songs like 'Waterloo Sunset' by the Kinks; tracks by the Small Faces, who lived in Pimlico; the Moody Blues' 'Go Now'; the Dave Clarke Five singing, 'I'm in pieces, bits and pieces.'

Well, I was in pieces now—waiting for my daughter to wake up!

Finally, I was allowed to sit with Anna in recovery, and then we were taken to the ward filled with kids who had had their tonsils removed. Poor little mites had bloody mouths and were all feeling very sorry for themselves, as was Anna, as the agitated nerve endings across the top of Anna's lip were causing her a lot of pain.

During the night, all hell broke loose when two boys who had been admitted from a war-torn eastern country rampaged through the wards yelling loudly. Their piercing screams made the hair stand up at the back of my neck. Anna and the other children sat up and started crying. They were all terrified by the guttural howling of despair coming from the young displaced refugees. This scenario puts everything into context. Our children had undergone minor surgeries and had safe homes to return to, whereas these boys would be scarred for life and had no homes to speak of. Our children were the lucky ones.

Divorce and Breakdown

The next thing to hit all of our family was the break-up of my marriage to Anna's dad in 1996. Andy had already left home and was living in a flat my parents had purchased for him for his twenty-first birthday, and Anna's half-sister, Claire, was living with her mum. It was therefore Anna and her younger brother by two years, Billy, who were most affected by the divorce. There is no such thing as a good divorce, but it would be fair to say ours was awful. It was as if a bomb had gone off and we had all been blown in different directions. One of the worst things for Anna was that our divorce meant she had to leave the comfort of her little private school and enrol at the large local comprehensive secondary school. It was a disaster. She had no front teeth and a head full of hair that had a mind of its own. She was a perfect target for the bullies, and bullied she was. Anna, who already felt like a freak, was paralysed with fear.

What started out a social anxiety problem eventually morphed into a full-blown eating disorder. She stopped eating and started smoking, and her weight dropped at a startling rate. Her voice was a hushed whisper and her handwriting was so small it was impossible to read it without a magnifying glass. Then, as soon as she was of legal age, she began to drink copious amounts of wine. It was a perfect storm. Like so many others she found inebriation relaxed her and gave her the confidence to socialise, albeit with just a few close friends.

I could see how things were unfolding, but I was having to deal with a house move that was stressing us all out. Our lovely, big home with rolling lawns was sold, and Anna, Billy, and I found ourselves in a small, terraced house. One of my friends hit the nail on the head when she gasped upon seeing it, 'You've gone from Buckingham Palace to Coronation Street.'

The good thing was it was close to Anna's and Billy's schools and public transport; the bad thing was that I was in the middle of a nervous breakdown. Stressful situations had been coming at me from all angles. I'd been studying psychodynamic therapy for three years and had been working part time in my small private practice from an annex off our home, but the money I'd made doing that was nowhere near what I had to needed to earn now, so I had no option but to get a full- time job. Anna and Billy's dad was now living with his girlfriend and I was earning too much money to claim benefits, but barely enough to pay the bills. All three of us were running on empty. I simply put my head down and carried on in the hope things would get better soon.

As I had already done some counselling in one of the London psychiatric hospitals, the then operational Charter Clinic in Chelsea offered me a position in their Marylebone in-patient unit that specializes in addictions and eating disorders. On one hand, I was thrilled—this was a fantastic career move—but on the other hand, it meant I would be away from home all day and would then arrive home exhausted. Anna would switch the oven on to cook whatever I had prepared earlier, and my parents would come over after school most days.

I felt I could do nothing right. I was too tired to give my job full attention, and I was stressed about being away from my youngest children for so long. It was far from ideal, but I wasn't the only parent trying to be a blinking superwoman. Still, I was failing my children, and I was falling short as a good therapist. My whole world had collapsed, and I had taken my two youngest children on a journey of insecurity. It was time to put a halt to my career.

After ending things with my clients at the hospital, I left and never went back to work in London again. Instead, I dissolved into a weird character I no longer recognised. 'Falling apart' is a thing that really happens. Some disintegrate, others drown, lots fragment, and some die. I couldn't die. It wasn't an option. I had to put my mental health first if I was to help my children.

Anna and Billy spent time with their father whilst I disintegrated even further in our Spanish holiday home. I went to view schools near Marbella. I dreamt we could all live there and start one of those new lives in the sun. This was never going to work, though, as my children loved their family and friends too much—Spain was my dream, not theirs. Billy loved going to Arsenal with his big brother, Andy. Anna had made lifelong friends in the neighbourhood and stability was the order of the day.

I was fragile, and my confidence had taken a nosedive. My self-esteem was in the gutter, and I felt such a failure. I honestly thought everyone was better off without me around. But this wasn't the case. I simply needed to raise my self-esteem and confidence—both of which had been shattered during an exhausting and demoralising divorce. These days taught me how difficult – seemingly impossible – situations can get better.

Anna's anorexia seemed to creep up on her, but once it became entrenched, it was impossible to try to reverse her way of thinking. However, she worked hard at school on the subjects she needed to get a place at the local art college and attended weekly counselling sessions. These were by no means easy years, but they were calm and stress free.

I began writing my first novel, *Coke on the Rocks*, under the pen name Lucy Wright. It was hugely cathartic and great fun, as I wrote about all the colourful people I'd met during the eighties and nineties on the Costa del Crime. The book was a big hit amongst the British ex-pats but I never marketed it in the UK as my finances were in dire straits.

Martin sold the Spanish holiday home and bought himself a boat. He decided it was time he took a well-earned rest and spent the next few years sailing around the Mediterranean.

I struck up a relationship with Billy's football coach, and we all enjoyed several years with our extended family. Weekends were all about sport. Billy was having a great time with his hobbies. He was enjoying tennis, for which he had a natural gift, and that led to him making the Surrey squad. But nothing could beat team competition. Tennis can be an insular game, but our local football club became our second home. It gave Billy the stability and fun he craved. And when, at the age of sixteen, Anna passed enough exams to be accepted into Epsom Art College to do a foundation course, we all slipped into an easier way of living.

We were happy.

4

Art and Design

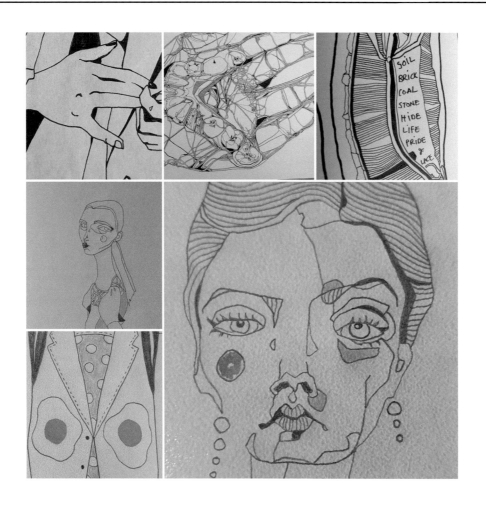

Anna enjoyed every single moment she spent studying fashion at the Surrey Institute of Art and Design. She made lasting friendships and had a great rapport with the tutors. I never heard her say anything negative, and it was within this environment that she thrived. For somebody who had struggled with high levels of stress, she found the deadlines stimulating and relished the thrill of drawing, cutting patterns, sourcing materials, making clothes, and finally dressing her models.

She was still living at home with me and Billy, so she didn't have to face the anxiety of leaving home to go to university. I was in a stable relationship with Billy's football coach, a man who'd known both of my children beforehand, and was very supportive. In fact, he bought Anna a top-of-the-range sewing machine. These were good times for all of us.

Anna won a national illustration competition and went on to illustrate for the BBC World Service. She was also chosen, along with eleven other students, to show her collection *The Elephant Man — Brutalities in a Victorian World*) at student fashion week in London's Battersea Park, and we all went along to support her. The dean of the university was delighted, and we were proud. The most

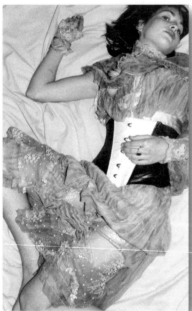

Anna modelling

Anna modelling , she was so happy at University

important thing was that Anna lapped up every minute of it, and although her name was lit up on stage, the thing that really choked me was the confident manner with which she directed her models and arranged the music.

She chose 'Beauty and the Beast' by David Bowie. It was quirky and completely the right tone for a catwalk show representing a freak show from Victorian London with folded silk tops in vibrant colours that represented folded intestines located on the outside of the skin, instead of being safely tucked inside the body. The exaggerated strut of the skinny models trotting down the catwalk in shoes like horses' hooves made for fascinating viewing, and the applause at the end was rapturous.

The upshot of all this success was that she was offered a job illustrating for the BBC World Service. This was an exciting time as her art was shown online world-wide. Then she and her friend Phaedra worked with designer duo, *Gharani Strock*, in northwest London, designing and making a collection of handbags. She absolutely loved it.

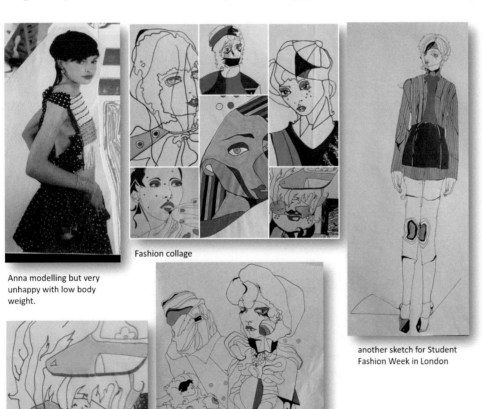

Anna modelling but very unhappy with low body weight.

Fashion collage

another sketch for Student Fashion Week in London

'Brutalities in a Victorian World - The Elephant Man'' Fashion show in Battersea Park, London

Fashion

'Elephant Man' drawing of John Merrick, whose story inspired Anna's fashion collection, entitled, 'Brutalities in a Victorian London'.

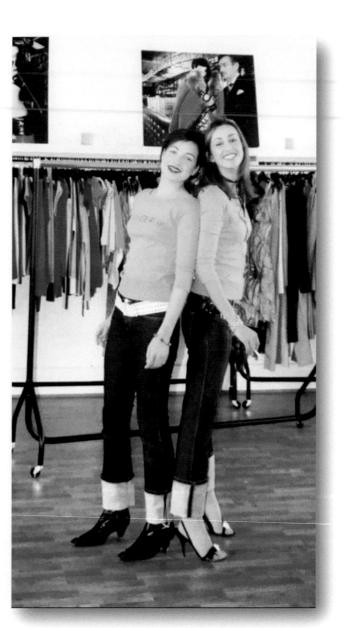

Anna and Phaedra working at Gharani Strock

Silk (purchased in Paris) vest which was designed with the thought of intestines being outside the body

She also enjoyed a fabulous social life—hanging out with Phaedra, Rachel, Lukia, and Sophie in Epsom. She was also still great friends with girls she'd met in school, such as India, Tina, Ruth, Michelle, and Selina.

This was such a beautiful time for Anna. She holidays abroad with her big brother, Andy, and his new girlfriend, Claire. She even had a couple of romances. But when it came to the choice of settling down, getting married, and having children or having a career and independence, the latter won hands down.

A really low moment came when she was one of the last two designers being considered for a position working with Vivienne Westwood. She was crushed when the other (male) designer won the job. She had been really excited and hopeful when she'd made the short list, and it took her some time to get over this disappointment. If I'm honest, she was socialising just a bit too much and consuming more alcohol than her body weight could handle, but my worries flew out of the window when a new, exciting adventure came her way that involved travelling to India. She had been headhunted to move out to Delhi for three months—all expenses paid—to design three new collections for several British high-street fashion houses, and she jumped at the chance.

5

Delhi and Sweatshops

Anna flew off to India fit and well, both physically and mentally. At five foot three, she was a healthy seven and a half stone—which was two stone more than she had been when she'd left school—and in good spirits. None of us were worried, and we thought this would help with her independence. But for Anna, this experience quickly turned into a nightmare. Somebody less sensitive would have coped; indeed, many did. The hotel was adequate, and her personal working conditions were good. The design offices were on top of a factory in the heart of India's infamous textile export industry. Her work colleagues were decent, and the job itself was well within her expertise.

This was the positive element of the whole experience. The negative proved to be highly dangerous.

Isolation and desolation set in almost instantly, and the flavour of Delhi didn't suit her personality. Maybe stronger characters would have looked straight past the huge cultural differences, got the job done, and seen the three months out. But for Anna, this was both a stark reminder of her happy childhood and a loss of a perfect life.

For Anna, travelling abroad meant a home in Spain purchased around the time she was born. Getting on a plane meant returning to familiar surroundings with her nearest and dearest—to the children's toys and beach balls, buckets and spades, blow-up flamingos for the pool, and sun hats and towels for hours and hours in the sun. From a very young age, all the children

had come out to eat in restaurants in Puerto Banus or the plaza in Marbella's Old Town. San Pedro was the town nearest us, and we would eat there all the time at plazas that gave them all plenty of space to run around safely and pick tiny flowers, which they squished together to make 'perfume'.

Even socialising in Spain had been a breeze for Anna, as some of our close friends also had apartments there, and we would all meet up every summer for six weeks. The local hotel had children's clubs close to where parents would socialise and sunbathe. At first Anna had been cautious, but the fact we were never far away and that the facilities included supplies for painting and drawing had soon made her calm and happy.

Easter had never been about the UK and chocolate eggs. Instead, we would attend the religious processions where we all followed a newly resurrected Jesus being carried through the streets on the shoulders of proud Spanish boys. The colours had been amazing, and although there had been drums banging and trumpets playing in the streets, the noise had been diluted by the open air and wide plazas.

Looking back, I believe Martin and I got it right by the lifestyle we chose to live. The fact that we were so family orientated kept all four children happy and healthy. Anna had never lived away from home. Her university had been close to her home in Surrey, where she was always surrounded by family and friends. The eighties and early nineties had been idyllic for us, with holidays in Spain, trips to Disney World in Florida, and hundreds of weekend visits to the south coast in our Morris Minor.

We'd always taken our beloved Border collie, Robbie, and would walk for miles on the beach and in surrounding fields. Martin would build makeshift barbeques on the beach, and we would feast on sausages, fish, bowls of salad, and French bread. In those days, we'd had a wonderful life, and there had been no deprivation whatsoever. We'd been a family of six plus the dog.

Christmas had always been special with gifts for everyone—My Little Ponies, Cabbage Patch dolls, and a delightful doll's house had been amongst Anna's favourites. Ducks and chickens had lived in their pens at the bottom of our garden, and there had been very little friction in our family. None of us ever dreamt it would end.

Compare this idyll to the childhoods of those Anna was now seeing in the poverty-stricken areas of Delhi, where children had been trafficked in from the countryside to work in horrendous conditions for a pittance, and you can only imagine her distress. Suddenly Anna was witnessing little children sitting in dusty alleyways playing with sticks, skinny from a meagre diet, while heinous crimes such as child trafficking and forced labour were hidden away from tourists. All this time, the wealthy shopped in designer outlets for elaborate, expensive clothes and wedding dresses costing up to $60,000.

She first spotted the children when she was smoking a cigarette on the rooftop of the warehouse where she was working and was instantly horrified. She cried and cried and cried. The poverty and horrendous working conditions were beyond anything she could've imagined. Through the window, she could clearly see huge spaces crammed full of tiny, grubby faces wearing sad and defeated expressions.

Anna couldn't have been a more sensitive child, and she was no different now when it came to such flagrant cruelty. When she had accidentally witnessed a bullfight on a Spanish TV channel at the age of 6, she'd immediately burst into tears. None of the other kids around had even noticed the spectacle on television. Now, almost two decades on, her sense of outrage at injustice was just as strong. Seeing such abuse up close and personal took a huge toll on Anna's mental health.

She felt guilty about the hand she'd been dealt in life compared to these poor little mites who were being exploited beyond belief. They worked for next to nothing. One report from the Save the Children movement placed their pay at around a hundred rupees a week, which is equivalent to one pound sterling. Their robotic work stitching sequins and beads onto garments stole the soul from their tired eyes, and their fingers were worked to the bone. There was no ignoring the exploitation of these innocent children, who ranged in age from five to fourteen.

In Delhi she heard the word 'backward' spoken so many times, as adult employers ridiculed the little ones. It sickened her. In some ways, she identified with the little ones. As a child, Anna had been referred to as a 'freak', her gummy mouth and crazy hair having set her apart from 'normal' children. When she'd been anorexic, she'd been convinced that everyone laughed at the way she walked. Anna had thought she walked 'funny', but she hadn't. It was in her head. No wonder she chose the subject of the Elephant Man for her fashion collection; she said she

could relate to John Merrick and all the distorted and disabled people who were cruelly paraded regularly in Victorian freak shows.

Each night, after working in reasonable conditions, Anna would be transported back to her very adequate hotel, whilst the youngsters remained hard at work. It would be yet another hair-raising ride back through Delhi, dodging cars, motorbikes with several riders, dozy cows, and the brightly coloured autorickshaws swaying about on three wheels. They would be serenaded by hooters, passing flashing traffic lights that no one took the blindest notice of. After all of that, she'd arrive back at her hotel, where she would drink the minibar dry and fall into a drunken sleep. Eating food was impossible. She couldn't digest what was going on all around her and, in turn, she was unable to swallow any nourishment.

This routine was repeated for six weeks until finally, exhausted and traumatised, she raised the white flag. Her weight had dropped dangerously low again, and her nerves were frayed. Thank goodness she didn't complete the three months allocated to the job, because the moment she landed back in the UK, she was admitted into a psychiatric hospital with exhaustion and in need of a detox.

It is astonishing how rapidly an anorexic can drop weight and an alcoholic can fall off the wagon. It takes so much more time to gain weight or detox and rehabilitate. It's also worth noting that if you only tackle the physical elements of the disease, it will return. I've seen it so many times at work. A professor I knew back in the eighties was convinced that if body dysmorphia was not tackled and corrected, an eating disorder was bound to hang around. Likewise, an alcoholic must attend AA meetings or stay in some kind of therapy—either one-to-one or group. There must be ongoing support from other addicts.

Anna responded well to treatment, but it took eight months to bring her back.

Ruby Two-Shoes

Now Anna looked closer to home for work. She resisted loud, belittling cries from some idiots who thought she should 'get a proper job'. Instead, she stubbornly stuck to her guns and, along with her good friend Rachell Bartlett Lamb (from university), set up a fashion business they called Ruby Two-Shoes. They did really well and peddled their quirky wares at the popular Portobello Road. Yet Anna's psyche was fragile, and her need to restrict food was always lurking in the shadows.

There was something battle-scarred about her, and life was getting her down. Anna was lonely. She didn't want marriage and children, but she knew something was missing. There was a void that she couldn't fill.

To be honest, her mid-twenties were difficult. She struggled with her mental health and found life exhausting. Don't get me wrong; she had good times and bad times like the rest of us, but this underlying low self-esteem was a constant in her head. Many thought she was 'fine', but she never hid from me how tough she found life. She thought she was odd, but I had always felt she was an old soul. There was wisdom in her huge green eyes.

As a child she would sit quietly and study people, listening to what they were saying as if she were making up her mind whether they were making sense. If she thought they were talking rubbish, she would never say as much, but I could always see it in her eyes. But if she thought someone was clever or funny and spoke her language, she would let them into her world and make them a true friend.

Just before she hit her thirties, my dad, who had been having mini-strokes, went into a decline. He did all he possibly could to hide his dementia from everyone. But he didn't fool me; he didn't fool Anna. When he died in May 2012, her granddad left her some money, affording her the chance to embark on the most exciting time of her life. With money in the bank and a body now refuelled, she marched forward.

6

Discovering Paris

Anna's first outing to France was in 2001, when the university took a group of students to Paris to buy fabric to use for their end-of-season collections. She was a typical nineteen-year-old with all her eating disorder troubles behind her and a new sense of self-esteem rooted in the knowledge that she was doing very well at the Surrey Institute of Art and Design. She had made a fabulous group of friends, and they were having a riot. They worked hard and played hard, consuming copious amounts of alcohol washed down with baguettes and delicious French cheese. They were a bunch of beautiful girls out on the town in the city of romance. Anna's love affair with Paris began then.

She bought some French Coco Chanel perfume and Yves St. Laurent make-up, but her favourite item by far was her bright-red Chanel lipstick. Anna's hair had changed during her teens. It had turned into a thick shiny head of raven hair that she wore in a trendy bob with a short, geometric fringe. Her skin was pale as porcelain, and with her rosebud lips painted bright red, she resembled a geisha girl.

On the final evening of this trip to Paris, she and her university friends partied hard. As they sat at a table in a trendy bar, her friend Andrew was using his video camera to capture the moment. Suddenly someone made a grab for the camera but couldn't prise it out of his hands. The man saw Anna's handbag sitting on the table, swiped it, and made off for the door. Phaedra said Anna was like a gazelle, and in a flash, she was onto him. She chased after the thief yelling, 'Oh

no you don't! You are *not* having my red Chanel lipstick.' She caught up with him and yanked her bag out of his hands. He let go and ran for his life.

From that day onwards she dined out on that story, and the subject even came up at the funeral, so legendary was her passion for red lipstick.

2012

A decade later, in 2012, she and I flew into Paris ready to celebrate her thirtieth birthday. We needed something to lift our spirits after her granddad passed.

We checked into a little boutique hotel set high up in Montmartre, just a ten-minute walk from Sacré-Cœur. We threw our third-floor window open and gasped as we looked out across the rooftops of Paris and at the Eiffel Tower. It was early evening, and the searchlight atop the tower was waving like a magic wand around and around, lighting up every section of the city.

We did our unpacking and then rushed out onto the little square, where an old man was sitting in the shade of the trees wearing his beret and playing his accordion. It was *so* French!

Anna was in a panic to eat—as well as being panicked about *what* she was going to eat. She always had to eat at 6 p.m., and the hour difference in France had thrown her, making her anorexic head spin. Our plans for culinary pleasures were thrown into disarray. All the menus listed outside the restaurants needed to be scrutinized, and as time swiftly passed, we decided to buy cooked chicken, green beans, cheese, and bread and take it back to our room. Whilst this was a lovely thing to do, it did what anorexia always did: took away spontaneity and pleasure. She got tense, I got snappy, and we both painted on smiles that didn't quite reach our eyes.

I always ended up eating far more than Anna, especially of the calorie-laden food, and invariably got indigestion. It was a very mother-daughter, dependent–co-dependent thing to do. Anorexics love to feed others, and others like me eat because we want to appease them. We think that if we eat more, they will follow our lead. They know they will always win this insidious game because they have all the control. It's a weird psychological game that is acted out time after time,

always with the same ending—mother full and miserable, anorexic triumphant. We pretend it's not happening because we want to keep the peace.

The following morning, Anna was, as usual, up early and hungry. Breakfast had always been her favourite meal. I, however, would have loved a lie-in and was still full of the previous night's feast! As I crawled from the bed, she was already dressed and hopping about, telling me to hurry.

As soon as we were up and out on the street, Anna came alive and excited for what the day might bring . Cafes lined the narrow streets, and the aroma of her favourite strong, black coffee welcomed us inside, where freshly squeezed orange juice, granola, and yogurt were all on offer. I couldn't resist a melt-in-the-mouth croissant, but Anna did her usual 'saving it for later' act.

Lunch was always a picnic, and I took great joy in watching her savour the flavour of brie on her baguette or jam on a crepe. She loved food as much as she had when she was a child, but now guilt always hung over her until the food was digested and she felt empty again. Even here, on holiday with me in Paris, she was unable to lighten up on the control she set herself when it came to food.

On her birthday, 6 August, we ate bread and cheese on the steps of Sacré-Cœur whilst looking across the rooftops of Paris. With most of the locals relocated to the Riviera for their summer holidays, the crowds were lively but limited. Men and women sold their bright souvenirs of the famous landmarks, such as Notre Dame, the Moulin Rouge, the Arc de Triomphe, and Sacré-Cœur. Bottles of water, cans of soda, and ice creams were sold from small vans, ensuring we were all catered for whilst we enjoyed the amazing vista.

Now it was time to go buy her birthday present. We headed off, taking our time whilst drinking in the heady atmosphere all around. We laughed at the little train that took tourists up and down from Place Clichy to the Moulin Rouge. It was a great way to get a guided tour all around Montmartre, taking in the artists' square, Picasso's house, Dali's museum, and the beautiful Musée de Montmartre.

Sometimes we jumped on the train, but it was so reminiscent of a funfair ride that we felt daft. Other holiday makers would point and laugh at the little train trundling up and down Montmartre, but there were days when our legs were tired and we were thankful we didn't have to walk.

My dad had owned a jewellery shop in Hampshire for fifteen years, and Anna had used to love watching him mending watches and deconstructing necklaces and bracelets. Doing anything intricate had always caught her imagination, and my dad had loved teaching his devoted pupil.

Anna's love of anything creative had grown dramatically from primary school all the way through to her university days. Art was her voice and expression, and it was often her creativity that pulled her through difficult times in her life. During this holiday, her body weight was very low, but her mood was lifting out of the pit of despair she had fallen into when her granddad had died.

She spotted the birthday gift she wanted as soon as we walked into a small jewellery shop called Corpus Christi Jewellers, (translated means The Body of Christ), which had unusual pieces decorating the walls. It was a gold bangle with a small, silver skull attached. There was an inscription running round it that said 'memento mori'—mori is the Latin word for death, but we didn't know that at the time! To buy a memento mori artistic creation is to remind people of their own mortality; it is Latin for 'remember that you have to die'. Anna didn't realise this until she moved permanently to Montmartre and made friends with Parisian artists. All she knew at that time was she wanted a memento to remember her granddad.

(After she died, I hunted everywhere for this bracelet, but it wasn't until almost a year later, when I was going through the jewellery she had made, that I came across the blue Corpus Christi Jewellers box. I wept buckets and howled to the moon in gratitude.)

During this summer holiday, Anna's mood lifted day by day, and so did her appetite. She rarely ventured away from what she called 'safe' food, but she did treat herself to lots of ice cream and cake. It was wonderful—just marvellous.

Whenever she was suffering badly with her eating disorder, life could be unbelievably tense, and there were many times that I almost banged my head against a wall with frustration. Fortunately, whenever we were abroad, her anxiety around food was moderated to a point where it didn't cast a shadow over everything. I was always happy to eat healthy food like fish, chicken, and salad or vegetables, but I also liked a glass of wine with my meals. Anna would scowl if I ordered wine—by now she had been dry for several years and still occasionally

attended Alcoholics Anonymous meetings—and so to keep the atmosphere light, I grudgingly abstained and tried to pretend I was equally happy with water. She knew I wasn't but was also terrified I would trigger her craving for alcohol. It was a tight rope we constantly walked to keep the atmosphere light.

Food and drink aside, we had such a beautiful holiday, and I was happy to see how relaxed she could be when she wasn't fretting about other peoples' illnesses. The weather was glorious, and the absence of locals meant that the queues to get into the popular museums, such as the Louvre, were almost non-existent, which was a great advantage. We also visited the National Museum of Modern Art, the Museum of Decorative Arts, the museums at Les Invalides, and on and on it went.

I say 'we' visited these museums, but apart from a sane walk down the Seine, I wasn't interested in the vastness of Paris. Years before, I had spent a weekend here with Martin, staying in expensive hotels, viewing France from the top of the Eiffel Tower, driving around the Arc de Triomphe, and eating snails and frog legs in posh hotels. Luckily, Anna loved to browse alone, and we went our separate ways on several occasions. As she would hop on the metro, I would hop into bed for a siesta. My back ached from climbing the steep steps of La Butte and back down again. Anna's thirtieth year coincided with my sixtieth. I was no longer a spring chicken, and arthritis had set in with a vengeance.

On our last day, we strolled around the Renoir Gardens in the Musée de Montmartre. We found these gardens on our last day, and what a find. This museum captured both of our imaginations, as this beautiful old stone building exuded history and romance. The artists Pierre-Auguste Renoir and Suzanne Valadon once called these beautiful buildings home, and what a home! With the Renoir-inspired gardens, the rustic benches, and the rambling grapevines, it was one of the most peaceful settings I've ever experienced—and I've been to some lovely places.

I am so glad Anna and I took photographs of each other in the garden, as one of my favourite photos of her is her sitting on a bench in Musée de Montmartre with a peaceful, faraway look in her eyes. It's one of those photographs that always makes me feel nostalgic and makes me miss her so much.

We talked about everything and nothing that sunny week in Paris. What struck me most was just how much she spoke of her love and admiration for my dad. Some of his monetary gifts had funded this trip, and now with her new bracelet sitting on her tiny wrist, she began to refer to him as 'Papy'—French for 'grandfather'.

It was whilst we were wandering around the beautiful St Jean Catholic Church, in place des Abbesses, that Anna sat down in a small, dimly lit corner and lit a red candle and began to pray. Tears began to silently roll down her cheeks, and soon she was sobbing. I sat down beside her. We both missed my dad so much. He was so wise and intuitive. Such a 'go-to' man who always seemed to know the right things to say when times were hard.

(After Anna had died, I came across something she had written about that day in the church. She'd said that whilst we were sitting in prayer in front of the candles, she had taken a photo, and in the flash of light, she'd seen a spiritual image. She was certain my dad was with us and we were safe).

I knew she owned a pair of little gold angels, but now as we sat there in the church, she told me that she had slipped one into his army blazer whilst he was in the coffin at the undertaker's. She also said that when she died, she wanted hers to be put into the palm of her hand. (Her wish was granted after she passed. We also placed some tobacco, filters, and rolling papers in the coffin, along with a red Chanel lipstick. I wanted every element of her personality and life to go to the next life with her.)

I thought this was such a beautiful thing. I also thought it to be quite a dark statement. I shrugged it off at the time, as she was grieving and also having a very religious moment. Anna never did anything by halves, and religion, from that moment on, became a big comfort to her. We lit lots of candles in the incredible churches all over Paris, including Sacré-Cœur and Notre Dame, and it seemed the Catholic faith had really made its mark. My maternal grandparents had been Catholic, as had my first husband's family; both came from an Irish background. Anna (and her little brother) had also been born in a small private hospital in Wimbledon that was run by nuns, so perhaps her pull to Catholicism was natural. Whatever the reality, Anna and I both found peace in those churches in Paris.

7

Loss and Grief—Christmas 2012

The Christmas after my dad died in 2012 was a family affair. We got together at my parents' house. We tried to make it lovely, but it was incredibly sad. My dad used to take delight in decorating the front door with colourful clowns and pretty lights. He would get involved with the cooking, and there had always been a real log fire glowing in a fireplace draped with holly, ivy, and mistletoe. Christmas cards would hang on strips of red crepe paper, and red, white, and blue paper chains would hang from the ceiling. The tree would always be the centrepiece, and its coloured lights would warm the room whilst we ate my mum's special roast dinners, raspberry trifle, and home-made Christmas pudding.

At our gathering in 2012, it became quickly apparent that Dad had been the heart of all celebrations. He'd taken after his mum; she'd been the queen of London on VE Day! She'd even managed to entice dance troops to our local recreation parks for parties. In many ways, he'd been nothing like his mum, but they had both loved to put on a show. All of us cried our way through the festivities that year without him. My mum cried all year.

True grief and feelings of overwhelming loss had yet to enter my world. I missed dad and everyone else who had gone before, but I would later learn that losing a child is on a whole new level. Still, for us not to have been there all together that year would've been wrong. We consoled each other as we listened to Christmas music on my dad's precious gramophone and watched Morcombe and Wise. The room wasn't nearly so warm without him. It was positively cool.

52

Everyone went home, leaving me and my mum in the house we'd moved into in 1956 when I was four. Back then, I had wanted to stay in my maternal grandmother's home, which was never cool (except perhaps in the outdoor loo) and was always filled with love and laughter.

Mum took some pills and a cup of tea up to bed whilst I gazed out of my front bedroom window, from which I could see the recreation ground and train tracks that divided the local community into labour and conservative sections. I had always longed to be on the red side where all my school friends lived, but with parents moving up the middle-class ladder (although still Labour), I didn't really belong anywhere—at least that's how I'd felt. Just like Anna.

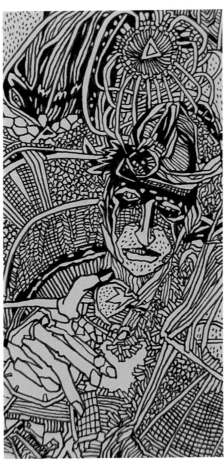

Internal Saboteur

8

Red-Light Christmas—Paris, 2013

It would be quite some time before we would all be together again. Instead, we all sought sanctuary with various aunts, uncles, cousins, and close friends independently. Anna and I were always together, though, and Christmas 2013 was another Parisian delight—and a Christmas different from anything either of us had experienced before.

We took the Eurostar from London to Paris for another adventure.

Eighteen months had passed by since our last visit, and they hadn't been great. My dad's death had left a gaping hole in our family. My mum, who I had never been especially close to, was very needy—not for me but for my son, Andy, whom she adored.

Andy was the most uncomplicated boy/man I'd ever come across. If he were any more laid back, he'd fall over. Now that he was married to Claire and his daughter Jessica had happily left

school and was at hairdressing college, all he had to worry about was his crazy Jack Russell and whether the weather was good enough for a game of golf or a ride out on his Lambretta scooter.

Billy had the travel bug, and I was glad about that. Anything to keep the depression at bay. Not that he was the depressive type—quite the opposite. He was an easy-going, funny boy who everyone wanted to be around. His friendships with everyone from old school and football-club mates to newer friends he had met whilst travelling the globe were solid.

While we were having breakfast at Paddington Station, listening to someone plonking on the communal piano, I caught Anna staring at my handbag.

'What?'

'It's tartan.'

'Yep, well spotted.'

'And why have you got that expensive coat on?'

I looked down and then back at her and shrugged. She'd lost me.

'You should never travel in posh clothes.'

'We are going to Paris for Christmas. Why wouldn't I wear my new coat and carry my red-tartan-and-black-patent handbag?'

'Because you look like a wealthy tourist. You will get mugged.'

I guess she had a point, but Anna could be quite obsessive about most things, so I put this down to her social anxiety kicking in. She was no longer the carefree student. Instead, she filled her head with things to worry about. By the age of thirty-two the anorexia had taken its toll not only on her mind but also on her body. She was taking medication for osteoporosis weekly after a scan showed that she had, and I quote the specialist, 'the bones of an old lady'. Her raven hair, still thick and luxurious, was already streaked with grey, and her once fine skin had recently

been prone to outbreaks of tiny benign cysts. Her nerves were so on edge that her hands would shake if she didn't take her medication, and her night sweats and tinnitus were driving her mad. Thank goodness she still had a grip on her wicked sense of humour.

We arrived at Gare du Nord at midday and took a taxi to the Pigalle district, where we were due to meet the owner of the small apartment that we were renting for the Christmas period. Anna had already started to research places to rent long term, so we thought we'd sample shopping and cooking instead of booking a hotel. The apartment owner was running late, so we decided to walk around the corner to where we had seen several cafes, including a Starbucks.

'We are in the middle of the red-light district,' Anna said, laughing. She was very open-minded and curious about sex and erotica. She loved erotic and horror movies. The 'goth' girl she'd been when she was eight was still in evidence. Back then she would never take her Doc Martens off (which drove my mother mad as she loved dainty shoes) but nowadays she loved her Converse trainers.

She pointed across the street to the famous Moulin Rouge nightclub and cabaret and grinned. Sex and windmills might seem a strange combination of 'favourites', but she had loved windmills ever since we'd taken her to the one on Wimbledon Common, which my dad had taken me to as a child.

Whilst Anna rummaged for some euros for coffee, I took in the atmosphere on the wide crossroads. It was busy, and it was cold. Anna handed me a coffee, and just as I reached into my tartan bag for some tissues, some bastard yanked it off my wrist and ran down the steps into the metro. Hot coffee sloshed everywhere, and far from running after the thief—no point, as they were probably already on a train—we just stood open-mouthed, gawping like a pair of idiots.

'I told you!'

Yes, she had told me.

The owner of the apartment arrived, and I nearly smacked him one for being bloody late. Misdirected anger at its best. Once inside the very cute high-ceilinged room with a red bed and

little blue kitchen, we took stock. I was not going to panic. I needed to stay calm and *not* spoil our Christmas holiday.

Anna gave me that old familiar grimace. 'Oh my God, Mum, what have you done now?'

(We quite often slipped into an Absolutely Fabulous mode, where she was sensible Saffy and I was all over the place like Eddy—what an incredibly spot-on observation of female relationships Ab-Fab was.)

'Right,' I said with conviction, 'no need to panic. It was a good job that I used to live on the Costa del Sol. I picked up lots of tips about dealing with this sort of drama.'

Anna's eyes went skyward. Any mentions of our mad Spanish days were never received well, and I must admit some of them had been hair-raising! Before Anna had turned into Saffy, she and I and our friends had spent many a mad week in Marbella and infamous Puerto Banus, but that's another book altogether—one that I had to fictionalise for fear of being shot by a drug dealer who recognised himself. The funny thing was, my acquaintances in the criminal fraternity all thought they were characters in the book when they read it and were over the moon!

'This guardia gave me a tip once,' I said. 'He told me to put half my money in my handbag and half in my pocket. Don't get into a confrontation; just throw them your bag. At least then you will be left with a credit card and half your cash in your pocket and therefore not completely destitute.'

'Well, what's been taken then?'

'Half my money and a credit card.'

'So, you still have a credit card … and how much cash?'

I counted out the cash that had been stashed in my suitcase.

'Three hundred euros and my savings credit card, so I can get more cash out of the hole in the

wall.' I was so calm that I didn't recognise myself. Had I been on my own, I'd have been pulling my hair out and slugging back a brandy.

'What about your passport?'

I turned green. 'It was in my bag.' In a flash, I added, 'But we don't need to worry about that until after Christmas, as we are not going back until next Monday.'

'It's Christmas Eve, and tomorrow it's Christmas Day, then Boxing Day, and then Sunday. The embassy won't be open. And don't forget you have to report it first to the police so you have a crime number.'

There was no arguing with that, but there was no way I was going to panic so she could follow my lead. It was Christmas, and Christmas we would have. I could worry on Sunday.

We went for lunch. Outwardly calm, I was certainly the duck whose feet were going ten to the dozen under the water. Anna took her usual eternity to choose her dish, and when it came to my turn, I simply said, 'I'll have what she's having'.

It was salmon. What could go wrong? The menu had been in French, but I had deciphered 'salmon' and 'salad.' When it came it was raw! I was freezing but thankfully ravenous, so I was able to eat it and, much to my surprise, loved it. I'd had steak cooked this way and nearly threw up. The fish was at least fragrant.

All I wanted was a Christmas with Anna and no dramas. We had decided to wait until we got to Paris to buy our presents and stocking fillers. We intended to walk up to St Jean Church and browse the little market stalls in the place des Abbesses. It was a beautiful evening and not so cold that gloves and hats couldn't put it right. We drank steaming bowls of hot milk and honey and chose little wooden decorations to hang on a small red plant we'd purchased at the florist shop to serve as our replacement Christmas tree.

The vintage clothes shops were packed, and I was reminded of the sixties and seventies when we used to go up to the little boutiques on Kensington High Street and the roads leading off it.

Biba would be buzzing with chic Mary Quant–style clothes and feather boas, and the markets were always filled with fabulous shoes, hats, and vintage jewellery. Back in the present, the smell of roasting chestnuts and mulled wine filled the air, and I was momentarily a teenager again. Anna and I sipped hot drinks as we watched the children screaming in delight from the carousel. We were both lost in childhood memories, as she had always loved the merry-go-round at the funfair. It was a beautiful moment—one of many.

After shopping, we went to the deli, where chickens were being roasted on a spit and all the juices were dripping down into a tray filled with garlic and herbs. It smelled divine, and we decided this would be our Christmas dinner. We chose green beans (lots of green beans in France) and already-made mashed potatoes, over which we were going to drizzle the herby juices. We also bought the obligatory baguette (nobody walks around France without one) and some croissants and jam.

Before we returned to the apartment, we visited the cafe where they had filmed the famous movie *Amelie*. It was utterly charming, and we got to chatting with an English-speaking waiter, who I think took a shine to Anna. He certainly gave her lots of encouragement about moving to Paris. When Anna suggested she might like to live in Montmartre permanently, he offered to ask his friend, who was an estate agent (of course he was), what the market was like.

Our intention had been to attend midnight Mass at St Jean, but we'd had a long day—and been mugged—so we turned in early to dress our plant with our new decorations and fill our stockings for the morning. We were excited and snug in our PJs and furry socks. What, we wondered, would tomorrow bring?

It brought a Christmas day of contrasts. We had split up whilst shopping in Montmartre, so we had managed to purchase lots of surprises. We had previously agreed that presents this year would be quirky rather than expensive, which was just as well, as half my euros were being spent by the bastards who had ripped my tartan bag off my arm. I had chosen to buy most of Anna's presents in the vintage shops, as she loved the shirts and jeans and woolly hats. I'd also managed to find a pretty, blue beret. She had bought me a camel-coloured fedora, so we were both suitably attired when we attended church on Christmas morning.

There is just something different about the churches in Europe. When Anna and her brothers were little, we had attended all the Easter parades (Semana Santa) and church gatherings in Andalusia, where we had a holiday home. We'd all loved following the processions through the crowded, narrow streets, where proud mothers would follow behind the huge floats on which their sons were carrying statues of Jesus. Good Friday's late-night penance processions had been dark and menacing, so we'd usually avoided this spectacle, but Easter Sunday was always beautiful. After the procession, the grand finale would be held in the square in front of the beautiful church. It had been a unique spectacle, with yellow carnations being thrown from the church tower down for the people to catch. After the service, a Spanish guitar player standing on an ancient grandstand would begin to play flamenco, and later in the afternoon, the dancers in their traditional dresses and shiny black shoes would join in. The air was always filled with the scent of meat and fish from the barbeque, and everyone from the age of two to ninety would dance. The Spanish do the family thing so well. Now, decades later, we were being reminded of past days when we had been one big, happy family in the Spanish sunshine.

Our funny little Christmas dinner was delightfully different. We managed to heat it up in the microwave, but we ate the chicken cold, as we were both wary of reheating the little bird. The herby gravy made the meal. Neither of us were ready for mince pies, so we went for a walk through Pigalle. The streets were lined with sex shops. They were closed, but that didn't stop us gawping at the gaudy underwear. The deserted alleyways added an extra flavour of mystery, and I didn't really want to think about what went on after dark.

It was as we were strolling down Clichy Boulevard that Anna spotted what was to be our next Christmas delight. She grinned from ear to ear and gave me a look that said, *I really want to do this, and I really want you to say yes.* She was rather like a kid in a toyshop who spies a soft toy she simply can't manage without and who stamps her foot a little if you dare say no.

We were standing outside a building with a flashing red neon sign that read 'Erotic Museum'. It was the only thing bloody open. How had she managed to find this oddity? In a leaflet she found at a *tabac* when she was buying her tobacco—that's where. She pulled the leaflet out of her backpack and declared it was the one she had been looking for! I shook my head in amazement.

'Nanny Beryl would've loved it here,' she cried, telling me that she was still thinking about family Christmases gone by.

Martin's mum had certainly always been up for a new experience and had always been the belle of the ball. She had been open minded and had loved to laugh. Anna loved her very much. My mum, on the other hand, would've had a blue fit, and my dad … well, he wouldn't have even set foot in a red-light district. Funny how different we all were.

We spent two hours in the Museum of Eroticism, where erotic art collections of antique dealer Alain Plumey and French teacher Jo Khalifa were on show. The exhibits were shown over six floors, plus a basement exhibition. Well, call me naïve, but I was shocked. Anna, on the other hand, was fascinated and engrossed by all the different artefacts that seemed to just keep coming, from floor to floor. One floor was devoted to legal brothels of the nineteenth and early twentieth centuries. The two upper floors had revolving exhibitions of works by contemporary artists. Round and round they went to make sure you didn't miss any angle! We had reached the dizzy heights of Parisian exotica. Some of the shows were permanent, whilst others were temporary, but they were all worth studying.

I learnt a lot that day—and I also wished her nanny Beryl had been with us. She would've lapped this up. There were relics dating back to prehistoric times. A sacred art collection demonstrated the ways in which humans have honoured the miracle of life with idols, masks, and other ceremonial objects that had been modelled, sculpted, painted, or engraved. There was no doubt this was incredible art. There was also no questioning how explicit these pieces were. They left nothing to the imagination. And although I was a bit creeped out, I couldn't stop looking. It was compulsive viewing. Anna was fascinated by the contemporary art collection that reflected the twentieth century's liberation of self-consciousness regarding the body and sex—something she had always found interesting.

(Sadly, the then eighteen-year-old museum is no longer there, as it was forced to close when the lease ended in 2016. Apparently, at an auction the two-thousand-piece collection raised 450,000 euros—tripling the presale estimate. This would be another example of how sex always sells).

That Christmas day, we perused all seven floors of the museum, and I couldn't help wondering who had bought all those sex chairs, ancient fertility totems, photographs of the Parisian brothel scene, and other artefacts, as well as the very explicit Japanese prints. I know Anna treated herself to some photographs, but although I'd enjoyed the experience, I didn't really want to buy a souvenir of a designer vagina. I laughed as my mind drifted back to my childhood when my dad would jump up and switch channels on the TV if anything rude came on. We'd had no remote controls then, so my dad would be up and down like a jack-in-the-box. He'd be turning in his grave if he could see these spectacles his granddaughter was enjoying. Funny old life.

Boxing day dawned bright and clear. We jumped on a bus that was heated and gazed out of the window at the other sights of the city. There were more people milling around popular places such as the Eiffel Tower, Champs-Élysées, and Place de la Concorde. The River Seine sparkled clear blue, and smartly dressed people sat in chic restaurants eating French cuisine. It was enjoyable, but—and I don't know why—we just felt more comfortable back in Montmartre.

By Sunday, I was feeling anxious about my passport situation, but I didn't want to drag Anna around to police stations and the British embassy, so I asked her what she would rather do?

'I'm going to browse the estate agents' windows to check out the price of long-term renting. Then I will go and see if Pierre is at Café Amelie.'

We arranged to meet there later. My mobile had been stolen, so we couldn't text each other. What a nightmare, really.

I found the local police station off the beaten track near place Blanche, not far from the Moulin Rouge and the coffee shop where the Christmas Eve theft had taken place. They asked why I hadn't reported it earlier but were very helpful. It was a bit tricky only having one credit card as identification, as they wanted confirmation of my address and date of birth and other relevant details. They asked if I remembered what my attackers looked like, and when I described them, the police woman gave a knowing nod and said they had a big problem with Romanian gypsies. It didn't really matter, because I wasn't getting anything back, and all I needed now was a crime report number to take to the embassy.

Visiting the embassy wasn't exactly a walk in the park. I didn't have too much trouble finding it, but when I arrived, it was closed. I started to panic. (I could panic now that Anna wasn't witnessing my spiral into orbit.) Anna had a hospital appointment to see a bone specialist on Tuesday that we needed to get back for. I decided I would step over the low metal rope that surrounded the embassy.

Bad idea.

Two soldiers guarding the main entrance turned their (big) guns on me, and I reacted by throwing my arms in the air and calling out in English that I needed to speak to somebody in the embassy. They took pity on me—probably thinking, *Wtf is this mad English woman on about?* —and rang the intercom. They spoke in rapid French, saying goodness knows what. After what seemed an eternity the door swung open and an English gentleman asked to see the documents the police had given me concerning the theft. To my great relief, he ushered me inside, leaving the soldiers holding their guns and laughing. They must have still been in the Christmas spirit.

The man asked me to take a seat and then made a call to an office in the UK. He said that as I was travelling on Eurostar, he could write me a temporary passport. It would not have been possible if I had been flying back, as the airports were very strict. I thought this nugget of information was worth storing away for future reference. I was very impressed—not to mention relieved—that I was able to leave with a legal document that allowed me to travel back with Anna the following day.

After running all over Paris and experiencing the fright of having guns turned on me at the embassy, I was a nervous wreck. I jumped in a taxi and was soon back on familiar territory. Anna positively glowed when she recounted her day with Pierre from the cafe. She excitedly told me there were quite a few little apartments up for rental in Montmartre, and glory above glory, there was an affordable garden flat tucked behind St Jean Church. I had no doubt her name would be on the door someday soon.

Off She Goes

We welcomed in the new year knowing Anna had made up her mind that Paris was going to be her home. She was thirty-two, and after having battled anorexia since she was fourteen, and alcohol and cocaine abuse during her early twenties, her body mass index was now, for the first time in ten years, within the safe range. We were all thrilled for her.

She quit her flat in Surrey and came to stay with me in Wimbledon for the weekend with all her essential belongings packed into a large suitcase and a backpack. It was late February, and with the worst of the winter behind us, she was looking forward to getting settled in by the time spring arrived in Paris. This was another one of those days that leaves an indelible snapshot in your memory bank.

We hugged and wept and laughed in the hours before she left. As she walked away from my door towards the waiting taxi, she didn't look back. I can still see her now in my mind's eye, wearing her woollen winter coat, jeans, and ankle boots. She had my dad's red scarf wrapped around her neck with her raven, bobbed hair tucked inside.

I waited until the taxi had driven away and then I cried. I was overcome with happiness for Anna and so proud that she had the courage to take herself off to a different country—future unknown. After the Delhi fiasco, I had feared she would never leave her sheltered life behind again.

I was certain her love for Paris was giving her the safety and freedom she craved. It was astonishing to witness the new, confident Anna. She was a healthy body weight and was close to being the girl who had stepped out into the lights during fashion week in London. She hadn't touched alcohol in years and never touched mood-altering prescription drugs. I was so proud. It was a pride that soared above any other feeling. I could have lived without her for the rest of my life as long as I knew she was safe and well—happy and content. Maybe she would even find love.

'All Over It'

'Bones and Teeth'

'Carousel'

'Fox Hunt'

'Hold Your Head Up'

'Grandad's Gramophone'

'Parrot'

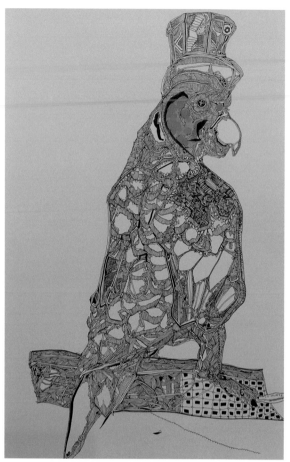

'The Wheel'

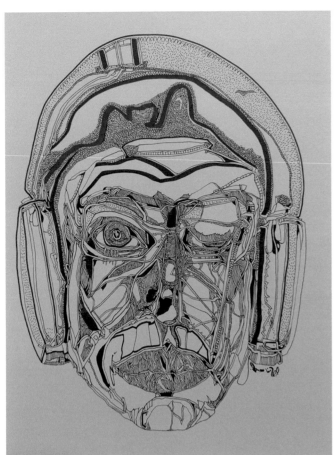

'Sound and Vision'

'Run!'

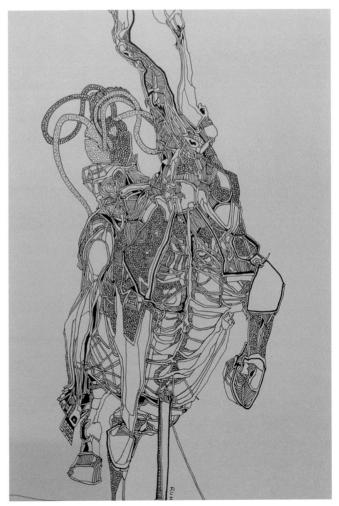

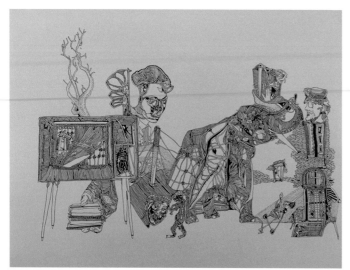

'Whale on the TV'

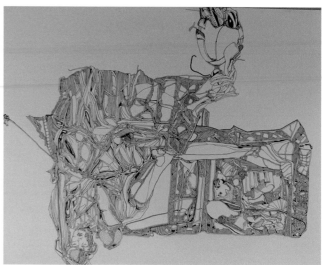

'Trapped'

'Little Brother'

Credits: 'Sono le sei meno un quarto' by Anna Wright, Laurence Mellinger, Alec Noat Dumeste, Jerome Barbe'
To be found at DESSINS PARTAGES - collection d'artistes.
All to be found at
https://galerie-dessins.blogspot.com/search?q=Anna+wright&m=1

9

Loving Manu: Soulmate at Last

Anna took to Parisian life like a duck to water. To be an artist in Montmartre was definitely living the dream.

After repaying her student fees, she had enough to fund herself for a year, but she was determined to be earning money before then. She never took one penny of the inheritance for granted. She had always been frugal and hated waste. She went mad when she saw food being wasted and was forever giving the homeless food and hot drinks—and she found as many homeless in Paris as she had in London.

The flat she had chosen to rent was tucked away in a side street behind St Jean church in place des Abbesses, in the heart of Montmartre. There were steps leading down into a small garden, and much to her joy, she got lots of visits from the birds. She made friends quickly, but trying to speak French was a trial. Fortunately, many of the locals spoke some English. She tried so hard, even hired a lovely lady called Brigitte to teach her, but she only ever managed 'Frenglish,' which was really quite funny. The postcards I received became more and more difficult to understand as French and English merged into an extraordinary new language. She had regressed to being that cute little toddler scribbling backwards.

Each phone call, email, and text message spoke of Alice this and Shirin that, and then it was Johanne this and Roland that. She sent me pamphlets with details about the latest art group she

had joined—Dessins Partagés. She adored sharing space on a page with other artists and was as dedicated to the work, just as she had been at the Surrey Institute. Later, in March 2014, they exhibited their work in Paris. The piece Anna had worked on together with Laurence Mellinger, Alec Noat Dumeste, and Jerome Barbe, was entitled *Sono le sei meno un quarto.* I was unable to visit this exhibition, as I was unwell. Martin went along, and I'm sure he was as proud as punch.

Anna lived around the corner from Picasso's house and loved to sit with a coffee by the carousel adjacent to the hotel we had stayed at back in 2012 for her thirtieth listening to the man playing the accordion.

Back in Wimbledon, I missed her like mad, but was so happy for her. I would've thrown my happiness into the ocean if it meant she was living her dream. As the spring warmed the air, I would sit writing on our bench on Wimbledon Common and wonder what she was doing. I lost count of the times she rang when I was sitting on that bench. I was joyful, but there was an ache in the pit of my stomach. Sometimes we cried together, but mostly we laughed. She was eating well and getting some sun on her body. Usually covered in layers of clothes, she had begun to wear T-shirts and pretty blouses with jeans purchased in the vintage shops.

Then one day, she called me in excitement. She had met a man whilst visiting the Louvre on the other side of Paris. Anna's landscape had moved beyond the boundaries of Montmartre, and she was having a whale of a time travelling on the metro and jumping on and off buses at points of interest.

They met in a print shop. Both of them had been printing off pieces of artwork, and it had transpired that both were living on their own. The man, called Emmanuel (Manu), was five years older than Anna. He was just out of a seven-year relationship, and Anna hadn't been in a relationship since she'd finished with a serious boyfriend when she was twenty-two. Anna had always put career before romance. Getting married and having a family had never been on her agenda.

'He noticed the feather tattoo on my arm, and he loved it,' she said. I could practically hear her grinning on the other end of the line. 'We are meeting for coffee later.'

I made myself a coffee. If he had seen her feather tattoo, the chances were that he had also spotted the scars on her forearm where she had cut herself whilst having a meltdown in Delhi.

Now I could hear nothing but joy, and it was infectious. I was so excited for her. It was only coffee, but hey, a coffee is a coffee. I just hoped he was kind.

He *was* kind.

I heard everything about him when she flew back in March to spend Mother's Day with me in Wimbledon. It was also Billy's birthday, and all the family was delighted to see her looking so well. We got to walk on the common, have a family roast at my mother's house, and visit our favourite places in London. Life was definitely moving in a positive direction.

By the summer, Anna and Manu had moved in together. Thankfully his command of the English language was really good, but I must say, her 'Frenglish' was becoming more and more bizarre. It was as if they had their own personal form of communication—rather like twins. It was so endearing.

Manu was also an artist. He loved making furniture, lampshades, and wall lights. His style was original, but like Anna, he didn't earn very much. They didn't give a damn, though, as long as they could buy a baguette and a packet of tobacco.

Anna laughed down the phone to me once telling me that he had found a purple T-shirt in the street. It had been hanging out of a skip! He'd added it to the pile of washing in the bag to take to the *laverie automatique* close to Abbesses metro station. (Lots of people used the launderette in Paris, as the apartments were often too small to incorporate washing machines or dishwashers.) How tall, lanky Manu with his unruly mop of dark curls loved that purple T-shirt. After that, Anna kept her eyes open to see what else she could find that had been discarded. They both loved to deconstruct items of clothing or furniture and became expert in creating interesting pieces of art from other people's rubbish.

Anna and Manu were madly in love. They spent the holiday together in their little Parisian apartment and took great delight in making their own Christmas tree and hanging decorations

and lights on it that only they could have created. It was a cross between Andy Wahol and an offering from a preschool child. They watched Christmas DVDs, such as *It's a Wonderful Life* with James Stewart and *The Snowman*. They also watched lots of French movies—thankfully with subtitles. They ate their favourite food, and it wasn't exactly traditional. They had similar tastes and both loved goat's cheese, peanut butter, dates and figs, and cake and ice cream—often eaten together.

Every day, Manu would take the metro to work in the printing shop whilst Anna worked on her group collage with Dessins Partagés, *collectif d'artistes.* These were idyllic days that unfortunately were about to be rocked by terrorism.

Anna on bench in Montemartre

10

Charlie Hebdo Attack

On 7 January 2015 in the late morning, just as Anna was walking back from the *boulangerie*, Paris was blasted from its usual peaceful reverie. The clock of St Jean had just struck 11.30 a.m. when her mobile rang. It was Manu, and he was hysterical.

'Where are you? Get indoors quickly. Hurry Anna.'

'What's happening?' she cried.

'I hear guns and screaming. I don't know. Just stay home.'

'Where are you, Manu? Don't go to the underground. Get in a taxi and come home.'

'I can't—the police are blocking the roads. I will stay in the shop, pull down the shutters, and watch the television.'

By the time he switched off his mobile, Anna could hear the screams of the sirens down the telephone line, and as she closed her apartment door behind her, she heard them for herself outside the window. She called up her neighbour Alice, and they huddled together, terrified.

This was the beginning of a three-day siege and bloodshed in and around Paris. It began in rue Nicolas-Appert, just around the corner from where Manu was working.

A black Citroen C3 had screeched to a halt in front of 6 rue Nicolas-Appert and was about to smash through the door before realising their target was Number 10, which housed the offices of Charlie Hebdo—a controversial weekly magazine. A female cartoonist had just returned from collecting her child from the nursery when two men dressed in black and carrying Kalashnikov assault rifles threatened her into revealing the keypad code for the second-floor office, where a weekly editorial meeting was taking place. The two masked gunmen opened fire, first killing the editor's police bodyguard before shouting at the others, demanding their names before shooting them. As the terrorists repeated their names in a frenzy, they added in Arabic, 'We have avenged the Prophet Muhammad. God is Great.'

The police arrived as the gunmen ran from the building and blocked their escape down a very narrow street. Journalists and office workers who had taken refuge on the rooftops filmed the scene. At one point, a terrorist shot a policeman and then walked up to him and shot him dead at close range. They abandoned their getaway car after crashing into another car, and then they hijacked a Renault Clio before disappearing.

All the while, Manu shook behind his desk, and Anna and Alice remained inside, listening to sirens screaming into the midday air. Paris was put into lockdown and on maximum alert whilst a major security operation was launched and an extra 500 police were deployed to the streets. By the time Manu arrived home, their nerves were shredded. Lovely, safe Paris had shocked Anna and left her nerves in shreds. She was about to beg Manu not to go into work the next morning when the news filtered through that two people had been shot in a southern suburb of Paris. Later news confirmed that a policewoman had been killed. The chaos that ensued lasted for days, but would be imprinted in the minds of those who witnessed this atrocity for a lifetime.

The drama reached fever pitch when the gunmen robbed a service station in the Aisne region, northeast of Paris. The manager of the service station said they had been armed with Kalashnikovs and rocket-propelled grenade launchers. A police chase followed, as the gunmen—brothers aged thirty-two and thirty-four—were pursued, leading anti terror experts to announce that the terrorists were at large, armed, and extremely dangerous. Ironically, the brothers eventually sought refuge in a printworks located in Dammartin-en-Goële, just twenty-two miles from Paris.

As if this wasn't frightening enough, another gunman took several people hostage at a kosher supermarket in the east of Paris after yet another shoot-out. All the incidents were linked to the same terror group. Anna and Manu had been caught up in a scene reminiscent of Kabul, and their world had been rocked. Anna said it was like a scene from the World War II movies she had seen on TV when Paris was raided by the Germans. We had watched so many movies about the French resistance at her Epsom flat when she had been sick.

Afterwards, Anna and Manu read the news in sober silence.

> Hundreds of armed officers surrounded the building, where brothers Said and Cherif Kouachi—the former bleeding from a bullet wound to the neck—had fled following a car chase. Elite forces deployed snipers, helicopters and military equipment—sealing off any means of escape for the suspected killers and beginning a tense, eight-hour stand-off. Both suspects were killed.

I used the word 'sober' because Anna almost fell off the wagon that week, and Paris was beginning to feel less perfect than she had imagined. She became completely panicked, and the PTSD she had been diagnosed with when she returned from Delhi resurfaced. She became clingy to Manu and stopped jumping on the metro and wandering freely about Paris. The only thing that didn't suffer was her art. She was writing lots of poetry and busied herself with what was to become her *Intense* collection.

Her concentration was at 100 percent, as she blocked out street life by wearing her headphones and listening to classical music. Manu found her a private local psychoanalyst, Sylvette, who really did save the day. She was marvellous. Although life returned to some kind of normality, Anna told me that she never really felt safe anymore. She said there was a tension in Paris that hadn't been there before. All the feelings of not being safe had flown back into her head, and her nightmares and night sweats had returned, leaving her exhausted. The big difference between her Delhi experience and this terrorist attack was that she wasn't alone when it happened, and that's what saved her from crumbling and falling down into a pit of despair.

11

met Anna and Manu at Paddington Station on 3 October 2015. I spotted them first and managed to scan a snapshot in my head of tiny Anna pulling her little suitcase and Manu towering above her, flailing his long, skinny arms as he tried to secure his backpack. I called out, and they turned towards me, grinning.

'Bonjour, Maman Rita!'

'Bonjour, Manu, mon fils français!'

Anna burst into happy tears and raced towards me for a long-awaited hug. We did a group hug before we moved off towards the escalator and a train to Wimbledon. We couldn't stop looking at each other, and we were saying all sorts of daft things like 'It's going to be a lovely weekend. Perfect weather for sightseeing.'

Manu was intrigued by the stories of the Wombles of Wimbledon Common. Anna had told him all about them and played him their songs. He said he couldn't wait to womble on the common and pick up rubbish. There was a really endearing childlike quality to Manu. He loved fairy tales and was in his element learning all the English childhood rhymes. Needless to say, being with Anna, his command of our language had improved extensively. He was almost fluent!

The next day was Manu's birthday—just a day before mine. We intended to celebrate for three days, and then the couple were going to visit the rest of the family. I bought him a shirt—I still couldn't get to grips with him being overjoyed at finding a *chemise* in a skip—and you would have thought I'd given him the crown jewels. We had a picnic on the common and wandered around the gardens behind Hotel du Vin Cannizaro. I was going to book one of their delicious afternoon teas, but Anna and Manu insisted on putting together their own picnic, just like they did in and around the parks and cemeteries in Paris.

On my birthday, Manu took himself off for an early-morning walk across the common, whilst Anna and I caught up on gossip over tea and blackcurrant jam on toast. I was so happy to have Anna back in my bed for cuddles. She had made me a birthday card—which is something she always did for birthdays, Mothers' Day, and Christmas or just because she wanted to or she felt I needed a special lift. My daughter had such a big heart, and if I was sad, she would call me a brave-hearted mum.

Manu returned with white lilies from the florist in the village plus a little posy of wild flowers he had foraged on the common for Anna. It was such a delightful morning. In the afternoon, we introduced Manu to the South Bank, and he wasn't disappointed. The book stalls and hot dog vans excited him more than the shops, and his reaction to the skateboard park was hilarious. He was a skateboarder! Who knew it? He was in his late thirties but suddenly a teenager. Someone let him have a go on his skateboard, and Manu entertained the crowd as much as the buskers and street dancers. It was fantastic fun; our spirits were free and easy.

Then we walked across the Millennium Bridge to show Manu the Korean War Monument that stood in the Ministry of Defence gardens. Anna's granddad had fought in the Korean war in 1950 and had watched most of his battalion killed by 'friendly napalm fire'. The South Korean government had erected this beautiful statue of a soldier with his head lowered holding a soldier's helmet. A carpet of poppies and small wooden crosses were laid by the soldier's heavy boots, and we always added poppies when we visited. There was a bench close by sheltered under the trees, perfect for a reflective moment, and we called it 'our London bench'.

Manu was a great fan of Sir Winston Churchill, and when he spotted Winston standing in Parliament Square, he was animated all over again. The camera clicked and clicked as he swung around, happily taking typical sightseeing photos of Big Ben and the Houses of Parliament. We were all free spirits that day. It was just a joy to behold. Anna and I were doubled over in laughter as Manu took on all the Japanese and their state-of-the-art cameras with his mobile phone.

Anna and Manu did the rounds of visiting the family before returning to Paris. Everyone loved him. Why wouldn't they? He was loveable. The fact that he was devoted to Anna was the cherry on top. They spent some time with Anna's nanny Beryl down by the sea in Lancing, and Manu was introduced to fish and chips. They also went to see her dad and his girlfriend and Andy and his wife, Claire. My mum cooked them a roast dinner, and Manu was enchanted by the flower-filled gardens that my parents had lovingly tended since the 1950s.

The subject of marriage and babies reared its head a couple of times. Manu definitely wanted a child.

He said to me, 'Yes, of course. My Anna and a baby and a dog. This is all I want.'

We all laughed good-naturedly, and much to my amazement Anna nodded in agreement, before whispering, 'Not sure about the baby.'

Suddenly my daughter was contemplating marriage and maybe even motherhood. This was a notion she had always been dead set against. She hadn't thought she was the settling down kind of girl, and having a child had always been at the bottom of her wish list. She'd always said she didn't want children and was even convinced she couldn't conceive. Whist it was true that a very low body weight means the ovaries shrink to the point that they don't produce eggs, it is also a fact that once normal healthy body weight is achieved, there is no reason a woman can't conceive. But Anna felt that she had damaged her body and even if *she did* conceive, she wouldn't be able to carry a baby to term. I feared motherhood was still far off as far as my daughter was concerned.

The pair of them were still contemplating moving away from Paris to somewhere tranquil. They were looking at little fishing villages in Brittany. I didn't know what to think. She had loved Paris so much. Was this Anna running from her fears and anxieties again? Paris and the artworld had taken her to their hearts just as much as she adored them. Was part of her self-destructing before the world could destroy her? As for Manu, Paris had been his home since his teens, but thankfully he was all for a move to the seaside. I simply suggested they didn't rush into anything.

Then the impossible happened, and it cemented their desire to run.

12

Terror and Bloodshed—*Vendredi* 13

It was Friday, 13 November 2015, when the Islamic State decided to retaliate against recent French airstrikes on ISIS in their stronghold of Raqqa, in Syria.

Paris had been home to Manu since his teens. Originally from Brittany, he loved living in the big city and had a great circle of friends. His life was there in Paris. His friends were there, as was his job and his social life. Meeting Anna—the English girl, as she was known amongst his friends—had completed his world.

It took one night to undo everything.

It was a Friday evening—Friday the thirteenth, unlucky for some but especially for the young Parisians who ventured out into the warm evening to meet up either to watch a friendly football match between France and Germany or to watch a band play or simply to catch up with friends over dinner or a drink. As the evening was pleasant, Anna and Manu decided to go out for coffee and a short walk to the fish stall on the corner of rue Lepic. They bought some prawns and clams for Manu to make soup and the obligatory baguette. They stopped off for coffee in Place des Abbesses, just across from St. Jean's Church and close to the steep stairway that leads up to the artists' square and then higher still to Sacré-Cœur. They returned to their apartment in the eighteenth *arrondissement* weary but happy. It was just after 9.30 p.m.

The drama began for them with a phone call from Manu's ex-girlfriend, Emily.

'Sava? Are you home?'

'Oui, quoi?'

'I think there is something bad happening. Stay home and do not go out on the street.' She clicked off, saying she was going to call more friends.

Manu shared the news with Anna, and they turned on the television. Anna couldn't stand football, but Manu was always interested in a national game, and that night, France was due to play Germany in a 'friendly'. As soon as the screen lit up, it was clear that there was something more than a football game occurring. Anna said she felt relieved when she knew the unrest was coming from the football stadium, as it was on the northern outskirts of Paris.

They could hear what they thought were firecrackers coming out of the TV. The noise disturbed Anna, and as Manu busied himself in the kitchen, she complained, 'Why does everything to do with football have to be so loud?'

The newsreader was saying that President Holland was at the Stade de France to watch the match but that there was nothing to panic about. That said, the president stood and left his seat discreetly. The fans inside looked anxious, and as more loud bangs filled the air, the tension became palpable. No sooner had an announcement told them to remain in the stadium than two suicide bombers, who had been trying to gain entrance to the game, blew themselves up. Security had been trying to avoid a stampede, but they did much more than that by keeping the terrorists outside. One suicide bomber blew himself up outside one entrance and the another next to the cafe outside.

The security services were taken by surprise, as there had been no intelligence whatsoever to indicate a terrorist attack. Then the police were informed that there were terrorists with Kalashnikovs in the heart of Paris. That's when the sound of sirens began to wail outside. At first it was just a few, but within half an hour later, sinister flashing blue lights lit up the whole of the city.

Anna was panicking, and Manu was frantically making phone calls. As soon as he ended one call it would ring again and another worried friend would be on the end of the line. Manu's friend Paco called to say the mood on the streets resembled that of the attacks on Charlie Hebdo .

Back in Wimbledon, I was enjoying a Friday evening with my cousin Sue and a few of our friends. It had been a trying week, and I was enjoying the prosecco with crisps and dips when I was first alerted to the nightmare unfolding across the water. We were playing music, so the TV was switched off. My phone was in the bedroom on charge, but Sue's daughter Laura had been watching TV when a newsflash alerted the British people of an impending terrorist attack in Paris.

Since we were an hour behind most of Europe, it was somewhere around 8.30 in the UK. Laura, just a little younger than Anna, was similar in character, and we often lovingly referred to them as being 'as daft as brushes!' Now Laura was hysterical because Anna wasn't answering her phone. Laura decided she was going to join us for company … and prosecco. 'Nervous Nerys', as we called her, jumped into a cab and was soon ringing the doorbell.

Manu called just after Laura arrived. By now we were glued to the BBC rolling news, and what was unfolding was horrifying.

'Where are you? Are you safe?' I cried.

'Oui, oui, we are at home—locked in. There are helicopters … It is terrible, quoi.' He ended most of his sentences with 'quoi' when he was hyper.

'Can I speak to Anna?'

Anna came on the line, started to say something, and then started screaming.

'The helicopters are in the sky again, and everywhere has turned blue! I think there are random shooters. I can stand it!'

There was no calming her. I told her to put her earphones on and play calm music, but she-was cross and said she needed to look after Manu because so many of his friends were out there.

'I hate Paris!' was her final shout into the air.

The TV stayed on, and gin and tonics replaced prosecco. We needed something stronger. It was horrifying enough watching the attack from the UK. I couldn't imagine how terrifying it must be to be trapped indoors with such carnage happening outside in the streets.

Manu is a sensitive guy, but he also possesses an inner strength. His attention would be on trying to make sure everyone he knew was safe whilst simultaneously trying to calm Anna.

It was 21.50 p.m. in France when the terror turned up a notch. As the group inside the Bataclan Theatre began to play 'Kiss the Devil' and the music roared, the terrorists stormed the theatre, shooting Kalashnikovs and spraying bullets everywhere. When journalists cry sentences like 'It is a bloodbath' or 'There is frozen activity everywhere', there is not much left to the imagination. When eyewitnesses are sobbing because they have just seen a severed limb and blood running down the gutters, you know this is an unprecedented event. It was reported later that the *fosse*, or orchestra pit, of the theatre was a mound of approximately eighty dead bodies.

Eyewitnesses, mostly bewildered survivors, were speaking from a place of deep shock, saying things to reporters that they had yet to comprehend, not that you could ever comprehend an act of violence on this scale. The news ticker running across the screen in Anna and Manu's front room was sensationally reporting on the unfolding story, filling all Parisians with renewed horror.

As roads were once again blocked off and helicopters flew low above the rooftops, Anna cried, 'This is war! We are at war! This world is going to end soon!'

This being the age of the smartphone ensured that graphic, grotesque images were flying all over the internet. Many years before I had noticed that European countries, unlike most British media outlets, showed every detail of accidents and crashes, as well as any terrorist attacks. When the Madrid bombings had taken place I'd been living on the Cost del Sol and hadn't been able to believe the horrific injuries that were flashing on the screen. They were so graphic I'd had to turn away.

Manu and Anna were equally freaked out by the sound and vision of the terrorist attacks. Manu had a broad social network in the city. He was an artist and enjoyed going to concerts. He even played the guitar and had been to the Bataclan many times. He was now about to lose friends in the attack; as was Emily. Almost everyone in the community knew someone who had perished. When would the next ISIS attack happen? Anna and Manu didn't intend to hang around and find out. As with so many places in Anna's life, once it had 'gone bad', she had to get out.

Anna started drinking and was a total mess. Her anxiety levels were off the scale and she needed silence to calm down and gather her thoughts about her future. (It was this weekend that she took herself off to the little hotel in Montmartre—where I would later stay with Manu and Billy in November 2019). She just had to leave Paris but couldn't walk away from Manu. She wanted to be at home with her family in the UK, but she didn't want to give up her dreams.

Anna went back to Manu, who had been comforting friends as well as trying to decide the next best move. Everyone in Paris was shell-shocked, and all anyone could talk about was the attacks. People in cafes and bars were still deeply traumatised. Eyewitnesses gave harrowing accounts of their experiences.

'I walked to the place de la République, and all I could see in my mind was a hill of bodies in the pit of the Bataclan. It is all over, but it's just beginning.'

'I wish I could cry to get rid of this stress inside.'

'I'm a dam that keeps bursting.'

'The only sound I hear now is the constant ringing of cell phones.'

'I had to make myself small and play dead.'

'I saw the gunman walking slowly towards me. He was going to kill me, but then he was distracted, and I lived.'

'There is no voice of reason after you have experienced so much blood and death.'

'I was crawling along the pavement. I was tingling and trembling. I want to see my daughter again. It took us four years to conceive her.'

'I was stuck in existential solitude.'

That final quote spoke to me on a very deep level. That is how we feel when grief cuts into our souls. It changes us completely. We are never the same people again. *Something fundamental* has shifted in our minds. Many experiences and events change us—it is how humans evolve and grow. Some things change us for the better. Some things change us for the worse. Small shifts happen all the time, and we flow and ebb with the tide. But when seismic shifts happen, we are left reeling. Likewise, if life gives us knock after knock without time in between to recover, a similar overwhelming feeling of not being able to cope sets in. Whether it's a sudden dramatic event or lots of little traumas, our mental health will be rocked.

Binic—Summer 2016

I had prayed that Paris would be Anna's forever home and that Manu would be her everlasting love who could make her happy and marry her—maybe they would have a child. But now, Anna and Manu packed up their belongings super quickly, and by the spring they were living in a sleepy little fishing village called Binic, quietly getting on with their lives together. They walked on the beach and swam in the sea. They took in a little stray cat, and now, happy and content once again, they both worked on new, stunning pieces of art.

Visiting Anna and Manu in Binic during the summer of 2016 for Anna's thirty-fourth birthday was a delight. It was a beautiful August, and we dined out on typical French foods, such as moules and frites, croque-madams and monsieurs, croissants, madeleines, and delicious pastries.

Anna's health was reasonably good, and her food restrictions were manageable. But she was struggling with alcohol cravings, which made her social life stressful. It upset her that everyone kept saying she could *surely* enjoy a couple of glasses of wine with a meal or a cold beer on a sunny day because she knew this would lead to bingeing on vodka. Her frustration was growing at the

lack of understanding about the danger alcoholism posed for the addict in the general public. Her 'sickness' was once again making her 'different' and casting her to the outskirts of society.

That said, Anna and Manu were happy enough to be speaking once again about their dreams of marriage and becoming parents. They even took me to the town hall where they would marry. I really *did* dare to hope. Anna had been vigilantly taking her osteoporosis medication and vitamin supplements and had been eating a healthy diet. They also walked on the beach and swam in the sea, as well as drawing and painting and making items of furniture. Anna had drawn her first image of *The Wheel* from her *Intense* collection, and between them, they found a physical wheel and set about upcycling it. They painted it white, and then Anna spent hours drawing illustrations on it. Manu made it into a lamp. It is an incredible piece of art that sits safely in Manu's art shop waiting to be exhibited—hopefully around Europe or even the world.

I have a grainy black-and-white photograph that Manu took of Anna laughing at me sinking into the wet, squishy sand. I was genuinely scared. I had seen films showing the horrors of quicksand devouring people and was in a terrible flap. Eventually I managed to break free and she thought it was hilarious. Manu captured Anna's belly laugh. It might be blurred, but there is no mistaking the delight she felt that day on the beach. We were all so very happy.

13

Two grandmothers in crisis.

I returned to the UK just before the August bank holiday with the knowledge all was well in my daughter's world. Not so for my mum. The poor thing had been becoming progressively more unstable since my dad's death in 2012 and had started having lots of falls. The first was a very heavy fall whilst she and I were on a coach trip to the Edinburgh Tattoo—an event she had been eager to visit, as she had been there several times with my dad. I had been astonished that she hadn't killed herself after falling down a flight of five stone stairs and landing on her head on the concrete, but she was only in hospital for forty-eight hours. She might not have died at that moment, but from then on, she began slowly slipping away.

My mum's last two years took a wretched toll on all of us—especially my mum, who repeatedly declared her life to be purgatory. We all witnessed up close and personal one hell of a lot of dementia during that time—from young women in their fifties right up to the elderly in their late eighties. Wet pants, toiletry accidents, dribbling food, walking into walls, wandering the gardens, cuddling dollies, and everyone trying to escape through locked doors that were always manned. Anna's worst nightmare was happening to her nan. She had been sectioned! She no longer had any control of her life.

Now back in the UK with us, Anna was swallowing diazepam and zopiclone again. Her rate of to-ing and fro-ing across the English Channel had been escalating at an alarming rate. Manu 's head must have been in a spin, as he wondered where all this chaos was going. But to us, it

was all part and parcel of the manic behaviour we all knew so well. Poor Anna was forever desperately trying to take back some control of her life – but the more she tried, the more panicked she became.

After two weeks, Anna had a meltdown about the doctors giving my mum the wrong medication and nobody listening to her about it. Anna was like a walking medical dictionary. There was nothing she didn't know about medication and appropriate doses. One day she couldn't bear to see my mum's distress anymore and ran away from the hospital, yelling that the staff didn't know what they were doing. I caught up with her and held her as she sobbed, 'They are going to kill my nan. Those antipsychotic drugs are too strong. She's only little.'

Anna would not leave my mum. Manu, meanwhile, wasn't able to leave France because of work; and their cat.

By Christmas, my mum was improving but was having bizarre hallucinations. Anna went back to Brittany for Christmas and new year, but she wasn't happy leaving her nan. During the first week of January, she flew back into Southend airport, and this time she had a bigger suitcase.

Anna took everything to heart and watching the decline of both her nans' health led to her eating and sleeping less. Her nanny Beryl had been admitted to a care home in Middlesex. The only blessing was that both of her nans' care homes were on the same railway line, because if she wasn't visiting one of them, she was visiting the other.

Beryl never lost her marbles, but after breaking her leg, she became very frail. Anna had lovely visits with 'Bezza', and they shared food. and books and laughed a lot. When Anna died, we told Beryl it was because of natural causes from her eating disorder, but I swear she didn't believe a word of it! She was a wise woman who could never be fobbed off with an untruth.

My mum was a different kettle of fish. Her hallucinations were getting worse and the images were becoming violent. She had been seeing little furry animals (she referred to as 'pukkers') that ran all over the place. They didn't frighten her, and neither did the horses she said she saw running past the window. But she had a new regular 'visitor' who would arrive in the middle of the afternoon and not leave until she managed to fall asleep. She said the man, who

was always dressed in a suit, would come across the ceiling and down the wall in a red car, and then he would threaten to cut her eyes out. By now, her eyesight was failing, and she was completely blind in her left eye. If I could've got her on a plane to Switzerland, I would've done it in a heartbeat, but we were going nowhere, as she was sectioned. The more drugs she took, the more she hallucinated, and the more she saw scary images in front of her eyes, the more she screamed, 'It's purgatory!'

By mid-February, my mum could only shuffle her feet and was almost catatonic. She was dying. The manager of the nursing home told us she wouldn't last much longer. Anna jumped up and down demanding a second opinion and wouldn't be silenced. She was researching psychosis and all different types of dementia, and the perfectionist in her ensured she left no stone unturned. Finally, she became convinced my mum was suffering from Lewy body dementia (linked to Parkinson's disease). I had never heard of it, but she said it was what Robin Williams had been diagnosed with before he'd taken his life. His wife had written an article describing his symptoms, and they were the same as my mum's.

Eventually my mum, who by now had a new consultant psychiatrist, was given the diagnosis of Lewy body dementia. Anna had been right. Her medication was changed and she perked up, finding pleasure in the little things in life that she could enjoy, such as visiting her brother and his family, and taking part in the activities in the care home. But a few months later, as the winter set in, I discovered my mum was losing blood and by Christmas she had been diagnosed with advanced bowel cancer, which meant she only had months to live. Anna and I sat in Costa Coffee at Kingston Hospital with my mum and broke the news.

'That's me never going back home,' she croaked . Her eyes misted over, and she went to some far-off place for a while. Anna and I simply sat in silence, allowing her space to think. My mum and dad had lived together happily in their precious home since 1956 which was a life-time, and it struck us that this distressing thought had only just hit her. For six years she had mentally lived somewhere in a pace called 'denial', believing one day she would be back there with her husband, Bob. She would be cooking dinner as he tended to the garden and then all of us would be coming over and be a family together as before. Then she snapped back into reality. She physically pulled herself together and brightened up with a wry smile. 'Well, I won't be eating that muck they dish up in that godforsaken place anymore.'

She had just been given a great excuse not to eat the rich, spicy food she abhorred.

From that day onwards, until she died in the summer of 2018, we used to take picnics to Richmond Park together. It was usually Anna and Andy's wife, Claire, in the back and mum and me in the front. We would have her favourite music playing, and she would sing her heart out to 'I Could Have Danced All Night' and 'Que Sera Sera'. These were such healing days for all of us but especially for me and mum, who were now devoted to each other.

She passed on a summer's day and then buried with my dad in Kingston Cemetery. She'd gone home at last – not to the house of bricks and mortar, but in heaven with her Bob.

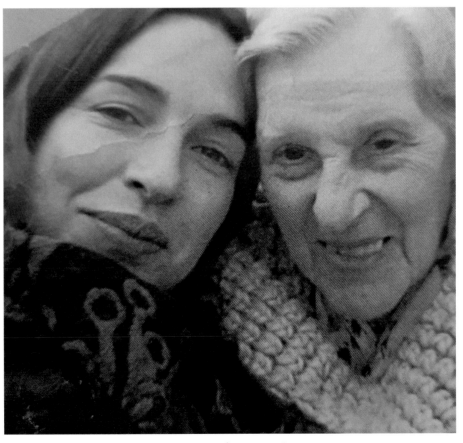

Anna and nanny Joy

14

Backwards and Forwards

Anna went back to Brittany. She and her dad took some of my parents' furniture over to France on the boat, and this time she was going to stay for good and really make a go of her relationship with Manu. No more backwards and forwards—just Manu and their art … and the cat … and perhaps a baby.

I intended to give Anna some money when my mum and dad's house sold, but the whole process of probate and the will and solicitors and estate agents was taking forever. I was hoping I could help Anna and Manu buy a little cottage in Brittany. I prayed they would have a peaceful life together in northern France.

Anna and I called each other regularly, and she was also in contact with her dad and Billy. We always spoke whilst I was walking on Wimbledon Common, and I would tell her which horses were trekking and how many ducks were bobbing about. She loved it when I said the heron was present. Coffee without her never tasted the same, and it was impossible to focus on a book. I just visualised her in the little park next to Abbesses metro station in Montmartre. It really had been a sad day for me when she and Manu left Paris, but hey, it was their happiness that mattered.

In March, the week before Mother's Day in the UK, I arranged to fly to Brittany. During a phone call, Anna asked if she and I could spend some time on our own, perhaps in a nice hotel. I said I thought it was a lovely idea, but what about Manu? She started crying and saying how they

were struggling. He would work late at night and into the early hours of the morning whilst she slept, and then she would be up as dawn broke and then draw until ten o'clock. He would want to go walking or bike riding, but she hadn't been eating properly and was exhausted all the time. The shingles she had been suffering from for years were getting worse, as was tinnitus. She was in agony with her hip, and the cold was making the screws in her ankle—the result of a compound break from her Spanish dancing days—ache. She thought the pins needed to be taken out: and she was right.

She asked if she could come back with me. For a break? For good? These important questions would be addressed once we were alone on Mothering Sunday. I said I would book a hotel close to Rennes airport and suggested the three of us all go for dinner together. They both greeted me warmly once I arrived, and off we went to a typical French restaurant that Manu had chosen. The tension was palpable.

After we said our goodbyes to Manu, I looped my arm through Anna's, and we walked slowly up the stairs to our hotel. She was pale and thin and clearly in a lot of pain. We went through the revolving doors and up to our comfy room, where we showered before slipping under the sheets of our little single beds. I was woken in the night by the sound of her in the shower—she had been having nightmares, and her sweats were awful. She came back to bed, slept again, and was drenched again. There was no doubt in my mind she had to come home. I had so many thoughts of *What if this or that happens?* that I was going out of my mind with worry. I couldn't chance leaving her there to die. She was so weak that she looked as if she would break. Some thought I should've been firm with her and told her to stay and work things through with Manu, but I knew the trouble was with Anna, herself, and not a relationship problem. That they were in love, was never in question.

From March, through to late June, Anna stayed with me. Manu kept ringing to see how she was and asked when she was coming back to France. She didn't know if she wanted to go back. She felt too ill, too tired, too weak. Her GP saw her every Friday, when she would give her a one-week supply of her medication, which was by now a mixture of citalopram, diazepam, zopiclone, and

pills to reduce the ringing in her ears. Years of laxative abuse had taken its toll on her tummy and bowels, and the shingles on her body rarely went away.

My mum's estate was still unresolved. The whole probate process was taking an eternity. I was desperate for some funds to be released so I could buy Anna a little studio flat down by the south coast. This toing and froing from the UK to France had to stop, and I felt that if she were to have a stable base of her own where she could make herself a little home, she might just settle down. I began to feel really weary, and my mood was low. I'd lost my mum and dad, one cousin had taken their life, another was close to death, and I'd had major surgery, from which I was still healing. I needed a little time out.

Anna stayed at my flat whilst I visited friends for a few days. Once alone she drank vodka and ended up in St George's hospital. I had begun to think I needed a bed there as well, and cried all the way home. On my arrival I didn't know whether to go to Anna in Tooting or to my very sick cousin in Kingston. To be honest, I didn't know anything at all anymore. Life had become a blur, and I was at risk of another burnout. I ended up going straight home and diving under the duvet. I simply couldn't face one more heartache.

I suggested Anna go and spend some time with her dad. He owned a summer house on the beach in Hayling Island. The apartment downstairs was a separate space he often rented out, and he said she could spend the early summer months there. It turned out to be the worst decision of my entire life.

Martin and his girlfriend were living in the apartment above the rental apartment, and I thought Anna would be safe and comfortable there. But the couple split their time between Hayling and their other home in Surrey, so Martin wasn't there all the time. I still thought she would be safe, as he had built two new beach houses and would need to be down there to supervise selling them. It seemed the perfect solution. Then maybe by the end of the summer, I would've received my inheritance. By now I was of a mind to buy a two-bedroom home for us to live in, with more space than my little flat.

Anna moved down there in June 2019, and at first all seemed fine. She was enjoying the beach with Paddy, the dog, and the sunshine seemed to be clearing her mind. As July moved towards

August, it was warm enough for her to swim in the sea, and she loved nothing more than collecting shells and visiting the local donkey sanctuary. Then she had to move out of the apartment because there was a rental booked. Her dad said she could stay in one of the houses he was selling. The floors in that house were still concrete, and there were no curtains at the windows. As there was a 'for sale' notice board outside, people would peer through the windows to look inside. She said she felt as if she were in a goldfish bowl and asked her dad to fix a duvet cover to the window.

We met for lunch in Portsmouth on 6 August, and there was absolutely no sign that she was in crisis. I had seen her better, and I had seen her worse.

She took her life the following week.

It is said that parents of children who have taken their lives shouldn't feel guilty, but it's impossible not to feel that there *must* have been something you could have done. Whether logical or illogical, the guilt remains, and the what-ifs drive you crazy. She only had to hold on a little while longer—but clearly, she'd had enough. It was her choice. It was her life.

Escape

15

Anniversaries

Rita soon after Anna took her life and she became a mother grieving a daughter for the rest of her life.

Our bench on Wimbledon Common. Once a joy but now great sadness

'Excruciating Anniversaries' Anna and her Nanny Joy

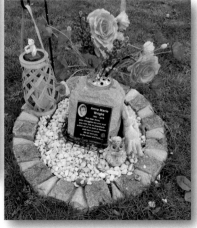

Anna's resting place in Surrey where family and friends visit regularly.

Paris 2020

I spent much of August 2020 in France. The Covid-19 lockdown had been depressing and isolating for everyone. We were all struggling to some extent, and even people with strong mental health tools seemed to be stuck between a rock and a hard place with new problems and so many deaths to deal with. Loss and longing hung around all of us. For some crazy reason, I thought that after the first anniversaries of Anna's birth and death I'd feel lighter and the intense grief would subside. Wrong.

On a hot summer day in early August, I took my cousin Sue's daughter, Laura, (who had never been to France and was eager to see all the sights Anna had loved) to Paris. As we stepped off Eurostar, Laura, with eyes wide, breathed in the Parisian atmosphere. I sensed she was trying to stifle her excitement because she felt guilty being there without Anna. I told her it was natural but that she should enjoy every moment and simply imagine Anna's spirit was with us every step of the way.

I introduced her to all Anna's favourite haunts throughout Montmartre, and I had chosen a room on the third floor of the Hôtel des Arts, opposite rue Lepic and just around the corner from Montmartre Cemetery. Laura was treated to a rooftop view of Paris and the roving laser of the Eiffel Tower. Watching her face was a picture. I was happy. I wanted her to feel, know, and love all the things Anna loved. Eating Anna's favourite foods, however, was a hollow experience, and that damn feeling of creeping guilt kept nudging its way into my consciousness. But being a tour guide was a lovely thing, and I relished every moment.

The weather was fantastic the whole time. In fact, at times, we ran for the shadows, where Laura introduced me to Aperol spritzes to cool us down and help relax us. We visited the churches and shopped in the souvenir shops for presents for her mum, Sue, and her children, Daniel and Erin. I'd promised them we would holiday there when they reached their teens, and they had been happy about that, especially when I'd agreed to Disneyland Paris.

One of the big lessons I learnt during the time of the first anniversary of Anna's death was that there is no getting over losing your child. None whatsoever. I had been ridiculous to think I would feel better after the first anniversary and that a little trip to put pink roses in Montmartre Cemetery would heal my soul. Instead, t he opposite happened. The empty space inside caused by losing Anna had grown wider and deeper. I was naïve to think I could move on and that the pain of losing her would ease in time. With this shocking new knowledge, I, not for the first time, sought solace in a therapist.

I knew how much therapy helped people and so I turned to a bereavement counsellor in the hope she could help me find a way to live with this tremendous loss. I sensed that if I was to stay alive, I had to learn some new skills to help me cope with this new world without Anna.

I instinctively knew the intensity of my grief would not miraculously subside, but I had to try to do something – anything – to turn the volume of my loss down to a bearable level. I sobbed through my personal therapy. I raged through art therapy as the drawings that emerged from my subconscious, taught me new things about myself. I was reminded of the woman I'd been before all the trauma and heartache smashed my soul to a million little pieces. I grieved for my loss . I grieved for the person I used to be. Once upon a time I had been funny and free-spirited but *who* was I now? Would I ever laugh again?

One day, I attended a group therapy session. During the nineties I had been a confident, professional counsellor, leading group therapy sessions, but right now I was the one needing help. All I cared about right now was pulling myself out of the depths of despair. There were ten of us sitting in the circle plus our therapist, Sam. We had all been instructed to write down about our feelings and then share them with the others. I listened, in turn, to what had been the catalyst that had brought them into therapy. We were all at the point of a nervous breakdown, each with our own unique troubles that had led to a crisis. A few of them were aware I had lost my daughter, but I was new to the group and they had no idea Anna had taken her life . I was also by far the eldest, but that never bothered me nor them. We were simply all entrenched in our pain and desperate for relief from our darkness. Most of them were around Anna and Billy's age. They all voiced suicidal thoughts, and it was with trepidation that I sat in group to tell my story.

I was aware that I kept my head down and didn't make as much eye contact as I would've liked. I just kept my head down and went for it. I told them the story I have told you. Halfway through I was aware that I could hear people crying—girls letting it all out and men, who had been trying to stifle their sobs, let their tears flow. It was a strange, uncanny sound that unnerved me. When I finished, by way of contrast, there was total silence.

Eventually I looked up, and was astonished to see that they had all stood up were clapping. I was overwhelmed; but so were they. One girl, who hadn't spoken to her mother for years after falling out over what she referred to as 'her unhealthy lifestyle' said she was going straight to the office to get her phone so she could call up her mum. She literally fled the room as if her life depended on it – which it probably did. Another young man who had tried to take his life several times gulped. 'I tried to hang myself, but the rope broke,' he said. 'I never dreamt my mum would go through agony like you've just described. I must try to get better.'

As everyone offered me their condolences. The sharing of emotions in that room was as powerful as anything I've experienced in my life. It was real. It was humbling. Organic and authentic. It was healing. I was acutely aware that the pain I had experienced on that first anniversary of Anna's death spurred me on to connect with others who were in similar situations. At the end, we all had our last hugs of the year, as lockdown number two was imminent.

The lockdown that followed was brutal for everyone. I had to keep reminding myself that I wasn't working on the frontline in an NHS hospital and should think myself lucky, but that didn't always work. Part of me would have rather been run off my feet, busy but surrounded by colleagues—doctors and nurses and carers—instead of being home alone, feeling sorry for myself that Anna wasn't there with me, that we weren't walking together on Wimbledon Common and down to the old windmill where we ate the sandwiches and drank coffee from a flask.

I was so lonely but grateful that my parents had died before Covid-19 slapped a ban on visiting care homes. We were all spared the experience of being isolated from each other. My mum would never have understood why we weren't all visiting her. If she had been told there was a dangerous virus killing everyone, she would've been beside herself with worry. My dad would've just slipped further into his cruel world of dementia.

How would Anna have coped with a pandemic? She'd already believed the world was a bad place that would end soon. Wasn't it best she had been spared the anxiety of coronavirus? I looked at everything from all angles, and when I was down, I tried to coax myself back to a level where I wasn't constantly floored with grief. I listened to the news with trepidation as the death toll kept rising here, there, and everywhere. The therapy reminded me of all the strategies I needed in my 'coping toolbox' to be able to carry on—whether calm or not.

Anniversaries, I realised, never got any better. Whether it is year one or twenty-one, it hurts bad. Being alone was dangerous, but when I contracted Covid-19 in late October 2020, there was no option. I called up friends and family and then became engrossed in writing this book as if my life depended on it, because it did.

Birthdays are brutal. Mother's and Father's days are cruel. Christmas will never be the same, and other special times that remind us of what we have lost are unbearable. That's life—c'est la vie, as Manu would say. Yet, for ourselves and our loved ones who are still with us, we must bear it. We must remember our loved ones and honour their memories. We must celebrate the lives they lived and build legacies upon what they have left behind.

I often touch the little 'Anna' tattoo on my wrist, and it brings me comfort. Getting her name and a little red heart tattooed was a spontaneous decision I have never regretted. But if I come across a photograph that I've never seen before, I burst into tears. When I found the art group website she belonged to in Paris and saw her drawing and name in black and white, I felt as if I'd seen a ghost. She came alive in that one piece of art. It was astonishing.

If a significant piece of music comes on the radio, I'm off again. When I see the solar lights shining bright on her little fig tree, I feel she is close, and it makes me feel warm. I am yet to walk along the River Thames in Southbank; it fills me with so many agonising feelings of loss that I rarely go—it is just not worth the pain. Not yet. All in good time … I guess. Baby steps, as they say.

What I'm saying is that anniversaries are tough and often unbearable. They are a time to get through rather than enjoy. Nowadays I speak to parents who have yet to experience the first anniversary of their children's deaths, and they are either filled with dread or wishing it would

Rita and Anna M Wright

102

pass quickly. I feel for them and tell them to simply get through it best they can; we will chat on the other side. It's truly heart-breaking.

We must survive these days of heartbreak. We must remind ourselves over and over again that although we have loved and lost; we *can and must* find a way to keep nudging onwards – and maybe even *upwards*. It is true that I feel Anna inside me. Just last week, the pain and loss was like a physical stabbing in my heart, and I found it hard to grieve. That night, I dreamt Anna was back here and we were walking along a road, pushing a baby in a pram. I looked at her and said, 'Thank God you have come back. The pain in my heart was so bad that I thought *I* would be the one visiting *you*.'

None of us escape grief. It is the price we pay for loving.

Rooftops in Paris

16

Anorexia

A sketch when Anna was a very depressed teenager.

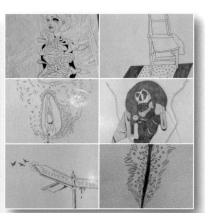

collage , entitled 'demons'

Anna's sketch of troubled England and Arsenal football player, Kenny Sansom, featured in 'To Cap It All' book Rita 'ghosted' in 2008

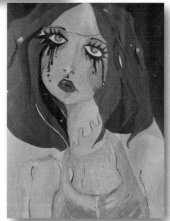

Self portrait of sad days entrenched in anorexia.

This book was a challenge for me to write, but the process of putting pen to paper about the subject of anorexia, although cathartic, has been especially painful. I had to wait until I was in a strong frame of mind to tackle this raw subject. There is so much written on eating disorders, and I've read it all—absorbed every word and scrutinised the topic from every angle. I worked with clients—both inpatient and outpatient—for two decades before changing direction and working as an addiction therapist on the Costa del Sol. I am not going to bore you with what you may think is psychobabble. Although I care deeply what Freud, Jung, Melanie Klein, and hundreds of other experts have written over the decades, I think it best to tell you, rather like a documentary, Anna's story. I will also share my first-hand experiences of working with eating disorders.

I have worked in many settings, beginning with an initial placement in the late eighties in the old Victorian hospital Atkinson Morley in southwest London. It is now a housing estate, and the eating disorder unit has moved to St. George's University of London in Tooting. The highly acclaimed Arthur Crisp, professor of psychiatry and chairman of the Department of Mental Health Sciences 1967–95, ran a tight ship, and the psychiatrist I worked with at Charter Nightingale (Lisson Grove, Marylebone), Dr Edward Stonehill, largely attributed our understanding of anorexia today to Crisp's brilliance. During the nineties, I was a volunteer for the Eating Disorders Association (now known as BEAT) based in Norwich and ran weekly self-group sessions, which helped those suffering to connect with other people with eating disorders. These therapeutic sessions, which take place all over the UK, enable isolated people to find some relief merely by talking and sharing. This fantastic charity is about to reach its fiftieth anniversary.

Today we use positive terminology of recovery and hope, and the word 'suffering' is frowned upon, even though what is happening is certainly deeply painful.

After I was awarded my diploma in psychodynamic therapy, I attended literally hundreds of workshops, seminars, and courses. Anna gets her tenacity and need to know everything from me. As a young adult, I worked at New Scotland Yard in forensics, where I was taught the arts of patience and scrutiny and taught that there is no such thing as a coincidence.

'Psychodynamic therapy' is a mouthful and sounds clever, but broken down, it is easy to understand.

'Psycho' simply relates to the mind.

'Dynamic' (as an adjective) means 'energetic' and 'active.'

'Dynamics' (as an abstract noun) means the motivating forces, physical or moral, affecting behaviour and change in any sphere.

This is the foundation from which I can reach into my other skills and adapt and modify aspects of humanistic, person-centred, and (hugely helpful) cognitive behavioural therapies.

Being eclectic in my work enables me to focus purely on personal autonomy rather than on a generalised label. In this section, I am going to speak from the heart as a mother who watched her daughter's progression through anorexia, which took us down dark backstreets and deep holes into madness reminiscent of *Alice in Wonderland.* It was tricky for me to juggle being a mother to Anna whilst having all the intellectual knowledge swirling in my busy brain—more so in her younger days than in her early adulthood. I had to check myself time and time again. *I am her mother … I am not her therapist.*

Let me tell you straight off that I have come to realise that, in my opinion, there is no final 'cure' as such. The focus of treatment needs to be about change, hope, emotional growth, and management. Self-awareness is paramount if a negative self-image is to be flipped on its head.

We can manage, modify, and even bury our troubles for a while. We can swap one addiction for a different addiction and then another and gain the label of 'cross addict'. But there is no getting away from the fact that the personality gene that lives in the head of the anorexic is so deeply ingrained in the mind that the most we can hope to achieve is some respite. If the strong will of the anorexic can dig deep to find control of their illness instead of allowing *it* to control *them*, there is hope of rising above it and using the creative talents that are almost always just a fingertip away. As the physical refeeding and therapeutic counselling progresses, recovering anorexics with newly fed minds find to their amazement that there *is* something they are good at, something they can achieve to raise their self-esteem, and that somebody *does* notice them behind their ghostly appearance. This is exactly what Anna did—not once, not twice, but three

times between the ages of thirteen and thirty-seven. She used the personality traits of the anorexic to haul her above the controlling voices in her head.

You can see her graphite drawing of her evil internal saboteur in this book. This was the name she gave to the punitive inner voice that ruled her with an iron fist. Anna managed several triumphs over the negative voices in her head and was able to find some pockets of true peace and real happiness, and this is why she was able to last on this planet for as long as she did.

Much is spoken about 'cross addiction' and quite rightly, because it happens all the time— smoker quits and begins to overeat, a drinker stops the alcohol consumption and starts to smoke dope, a bulimic swings the pendulum between starving and binging, a workaholic becomes a gambler, and so on. This is the nature of the beast of addiction and disorders. Yet there is almost always a primary force that triggers a specific personal mental health problem. Anna's was social anxiety.

A Dangerous Way Out

Anna simply couldn't cope with the bright lights and noise of life on earth. Her innate anxiety and panic that set in when she was challenged with sensations outside her comfort bubble was simply not containable. Staying home with her family or being creative in a university surrounded by friends who literally and metaphorically spoke her language was bliss. The more time she spent in these two environments, the more she calmed down and thrived. Her confidence built, and she gained weight.

With her brain fed and functioning, she was able to create a fashion collection and continue from the drawing board to the catwalk with complete focus. It seemed a miracle to us—her family—that she could fit the models who walked her clothes down the catwalk before strolling out into the bright lights that shone above her, spelling out her name. For her to enter the stage and take a bow with such confidence was incredible. Can you imagine our delight? We really thought her anorexia was dead. What an insidious illness!

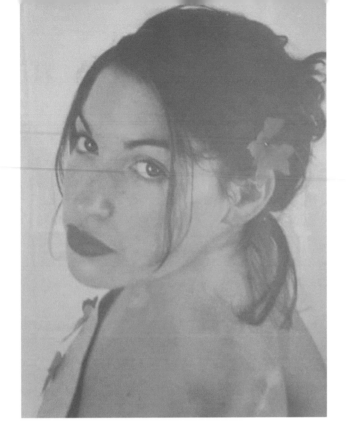

Anna was confused as everyone was saying how great she looked but inside she was dying as she felt so ugly

Her social anxiety led Anna to find a way to avoid stressful settings, especially in secondary school. If she was sick and weak, she could stay home in a bubble with me and her other family members, but this meant she was avoiding life and all it has to offer and teach us humans. Nature screams for progression. Our life-and-death instincts and impulses are in constant conflict.

Working with eating disorders is an enormous challenge, and therapists who do so need to be highly experienced, as this really is a case where knowing just a little is dangerous. I was so lucky to have amazing tutors when I was learning all about psychodynamic therapy, and two of them were eating disorder specialists. My supervisor of five years worked at London's Tavistock and Portman Centre in northwest London—a centre committed to the care, education, and treatment of patients with eating disorders to enable the improvement of their mental health and well-being. Always ahead of their field, they also focus on gender identity development.

Halfway through my three-year training, a woman came and gave us a lecture on eating disorders. She was from Australia and very engaging. At one point, I asked her if she had

found a common denominator in the people she had worked with, and she answered with an emphatic yes, and went on to explain, ' We all lose our innocence at some point. The children of today lose it way younger than my generation and the generations before . It is simply how we are evolving—too fast for our human brains to keep up. Thousands of children, teenagers, and adults of both genders have all lost their innocence far too young, before their minds have developed into mature adulthood. If they lose their sense of innocence before the age of seven, they are likely to suffer later in life'.

Innocence. One word.

Definition of 'innocence': lack of guile or corruption, purity. "The healthy bloom in her/his cheeks gave him/her an aura of innocence."

As Anna matured, she was able to verbalise a ghostly experience that remained a faint recollection or a momentary jolt of a fear that didn't make sense and therefore could not be put into words. All she knew was something had happened that had scared her – something that didn't feel right, but she was too young to fathom what it was. Universally this phenomena will put doubt into a child and leave them wondering, *Did that just happen, or did I imagine it?* This fantasy versus reality has been written about by many prominent psychologists and psychoanalysts including *Donald Winnicott* who introduced the concept of the true self and the false self. He used these concepts to describe a sense of 'self' and described a 'false self' as an artificial persona that people create very early in life to protect themselves from re-experiencing developmental trauma and shock and our delusionary self-creation can stand in the way of our real authentic self. Our defences prevent us from experiencing the truth of ourselves.

I believe it is true that we can forget an incident but never forget the 'feeling' it inspired. That 'feeling' is stored in the cells of our bodies, and there is always the potential for it to rear its ugly head.

When I think of Anna's mental health problems much of what *Winnicott* tells makes sense to me, and when we look at her art, we can almost see her psyche on the page. All of the false/

negative fear is there in black and white. *Who am I really?* This was a question I often heard her cry as she struggled with her inner demons.

Many people I have counselled had their precious innocence stolen before they could mature to a point where they could safely manage what was happening and see it as a clear reality. They were filled with anxiety, panic and a deep fear. They fear that what has already happened will happen again.

Hypervigilance and the need for heightened control will be the anorexic's constant companions along their tricky path through life. The anger that is expressed comes from the fear tucked away in their now fragile minds. The sadness in their eyes speaks louder than their voices. The English poet John Milton wrote, 'Innocence, once lost, can never be regained. Darkness, once gazed upon, can never be lost.' Whilst this is a depressing thought, I do believe there is more than a grain of truth in his words.

A psychiatrist I once worked with set out the following characteristics as an indicator of somebody in danger of developing an eating disorder.

- Shyness
- Introversion
- Dependency issues with their mothers
- Perfectionism
- Anxiousness
- Nervousness
- Hunger for a father
- Stubbornness

They may as well have thrown Anna's name in the hat!

Western society, which has insidiously drip-fed youngsters with images of skinny people and spewed the message of perfection into the faces of the imperfect, has much to answer for, and as for social media and trolls—be very ashamed! But these are not the root causes of anorexia; eating disorders begin way back—maybe even in the womb or in one's DNA. Anorexia is a coping

mechanism gone wrong. What begins as a dear friend (a way of behaving that leads to a much desired weight loss) eventually becomes your worst enemy (you get sick) who puts your life in danger. 'Torture' is really not too strong a word to use to describe what anorexia does to a person and their family.

SUICIDE AS AN ENDGAME

Suicide is the endgame in this tug of war between the extremes of good and bad – reality and fantasy. After years of low self-esteem and listening to the critical internal voice that bangs on and on about what they should or shouldn't do, the sufferer is in such a state of exhaustion that they seek a way out of their misery. I believe very few want to die—they just have to stop their world and get off.

If we are to understand this terrible drive towards suicide, we have to understand what it really is that we want or need from our loved ones and how to communicate that need. If we have lost sight of who we really are, how on earth can we reach out and explain ourselves to others? On the surface we seem OK.

How many times do we hear grieved family and friends say they didn't have a clue anything was wrong with their loved one.

Anna seemed in a good place when she took her life. There were so many times in previous years where none of us would have been surprised if she had taken her life—but not in the summer of 2019. But she *had* voiced that she felt worthless, and she *was* feeling exhausted. Was this exhaustion about feeling, for far too long, that there was no way out? She used her art in her desperate attempt to communicate to us how she really felt. She did not have the emotional strength to take part in an exhibition in Paris and show us her *Intense* collection because she feared failure; but also feared success. To fail to impress would have been experienced as a rejection, not just of her art but of her whole being. Because she *was* her art.

Her drawings and poems speak of feeing trapped inside a mind that couldn't directly communicate her fears and anxieties. She couldn't bear the loneliness—the pain and suffering—that being inside her head caused. It became too much. If Anna hadn't had her art to help guide her navigate herself through an internal world that was depressed, and an outer world she felt had gone bad, I believe she would've died many years earlier. Her creativity gave her great expression, and her improved mindset and maturity enabled her to fall in love and be happy. Yet the physical and mental scarring were now so deep that her personal life, her love life, and her life as a whole had chronic limitations.

17

Mentors and Influences

Anna felt a great connection to so many creative people, whether they were friends and tutors or famous artists on the world stage. Her understanding of the written word and the rhythm of poetry brought her hours of pleasure. She gained so much from studying the work of her mentors, either by listening to their music or reading their literature and poems.

Her choice of mentors was eclectic and diverse. Patti Smith was one of Anna's idols. I think she longed to be successful and revered as much as this American legend who not only possesses an innate talent but has the personality to succeed in a tough, competitive world. Anna bought into the notion that Patti 'had it all'. 'These Are the Words' was played at her funeral. Every time I hear the haunting 'la la la la la la la la la la la' of that song, I can see the pretty wicker casket covered in white flowers that held my beautiful daughter's body, and I shiver—like someone has just walked over my very own grave.

Modern pop music was not for Anna. Give her Bob Dylan and Nick Cave. Dusty was her dream singer and Madonna a great favourite of hers. Amy Winehouse made her cry, as did George Michael. Bowie brought her alive with his vibrance and flair.

During the last ten years of her life, she read everything from Freud to Graham Greene and Spike Milligan. When Jim Morrison wrote, 'I'm kind of hooked to the game of art and literature; my heroes are artists and writers,' he spoke Anna's mantra. Although he never wrote books, I

think he would've liked to—but his songs and poems were cracking. This great rock star moved from America to Paris, and it was here that he was also found dead. He is also buried in Paris. He, along with so many other great stars and artists, died at the age of twenty-seven. I believe Anna would have joined the '27 Club' if she hadn't had Paris to spark her into life for her last decade—her last hurrah.

Anna's biggest disappointment in her fashion career was coming second in a round of interviews to get the chance to work with Vivienne Westwood. To come runner-up in such a contest and lose the opportunity crushed her, but she still always loved anything Vivienne designed. She sobbed when Alexander McQueen died and was very vocal about how many amazing people were taking their lives.

We now know that trauma can challenge the whole meaning of a person's life and their sense of purpose. Unresolved trauma that is buried deep in the psyche will one day surface. Anna's awful experiences in Delhi and Paris led to deep psychic trauma. Today, the medical staff working on the frontline in Covid-19 wards have their own unique sets of nightmares to process. In a newspaper article and a TV documentary, Professor Hugh Montgomery explained how medical staff all took it personally when a patient whose hair they had brushed or whose bodies they had washed passed away.

'It is illogical, but that is what the human mind does—feels responsible and guilty.'

He went on to talk about the rising levels of PTSD and burnout among the staff, and that numbers are only going to increase. With flashbacks and nightmares inevitable, it is no wonder PTSD triggers suicide.

We all start out in life imagining that we live in a bubble of invulnerability from the dangers of the world at large, believing that bad things only happen to other people. As we travel through life and we receive little knocks, like losing a pet, a grandparent, or someone else we love, reality begins to set in, and we start to understand the meaning of life.

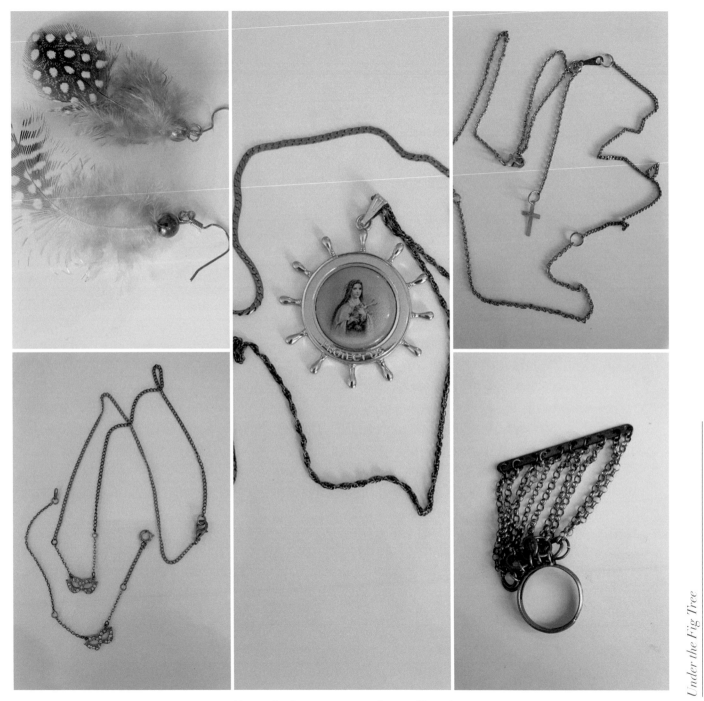

'Anna's deconstructed jewellery'

18

Suicide in Prisons and Remand Centres

I was really introduced to the subject of suicide in prisons and remand centres when I met Erin Pizzey, who wrote the foreword for this book. She is a mighty force with a huge capacity for love and a tenacity and determination seldom seen in humans. It was almost fifty years ago when she set up the very first safe shelter from domestic violence. I happened to live close by in west London and have followed her great work over the decades. When our paths crossed during the Covid-19 pandemic, she was grieving the loss of her precious grandson Keita, who had taken his life whilst on remand—yet to be convicted of a crime. We shared our feeling of immense sadness, and now a photograph of Anna sits in her living room alongside a piece of art Keita had gifted her.

Once, when Anna and I were perusing an art gallery in Southbank, we came across an exhibition of art and poetry created by prisoners that made her cry. Her empathy for anyone struggling knew no bounds. She had completed a teacher-training course in her twenties and had often voiced her ambition to work as an art therapist in prisons.

After meeting Erin, I quickly realised this subject received too little attention, and as I watched Erin's grief etched into her now elderly face, I began to think about how the parents, partners, siblings, children, and grandparents of those incarcerated suffered. Suicide should not be an

option for prisoners. They are held, we say, at 'Her/His Majesty's pleasure', a phrase based on the concept that all legitimate authority for government comes from the Crown.

Erin shared her grief and determination to change the law concerning suicide in remand, in the foreword of this book. This formidable but gentle soul touched my heart, which meant I had to do some research of my own. I uncovered much more than I bargained for, which is why I decided to include this subject. The experts offered great insight into not only prisoners but the whole big picture of suicide. I came to understand just how much 'prisoners lives matter' and realize that they need voices on the outside to educate society. I searched government papers and googled 'suicide in prisons', and I found interesting facts and figures. As I delved deeper, I uncovered several books, which I have listed at the end of this book.

Being arrested is a huge trigger for suicide. It sets in motion a train of thoughts that can lead to the act of suicide. I thought about Erin Pizzey's grandson, who hung himself with his shoelaces when, instead of finding him a bed in a mental health facility (there were none), the officers threw him into a cell without charges. When Keita was remanded in Richmond, the officers took away his laces. Yet later, whilst in Wandsworth prison, somebody gave them back to him. He was in their care and innocent until proven guilty. Where was the justice? And why was the person who returned the laces that he killed himself with never named?

There is strong evidence that research into suicides in prisons is in a bad state due to lack of theoretical evidence. How can this be?

What *do* we know? We know that the moments in which prisoners are at the highest risk of committing suicide are:

- early days and weeks
- post transfer
- post recall
- post sentencing.

Someone in crisis may:

- be visibly agitated
- express suicidal intent
- actively engage in self-harm or suicide attempts.

One theory holds that the risk of suicide is heightened when a person who is arrested:

- lacks a sense of connectedness
- feels like a burden
- is hopeless, believing that things won't change.

I would argue these are the primary concerns of *anyone* feeling suicidal.

A paper published by Her Majesty's Prison and Probation Service on 15 May 2019 entitled 'Suicide and Self-Harm Prevention' states the following:

> Self-harm can occur at any stage of custody, when prisoners are trying to deal with complex and difficult emotions. (I could certainly equate Anna's triggers for suicide being linked to these thoughts and feelings).

1. An impulse to punish themselves.
2. Expressing distress.
3. To relieve an unbearable building tension.
4. A mixture of all the above.
5. A cry for help … never think a cry for help is mere attention seeking … these cries cannot be ignored or trivialised.

Mental health issues in prison run high (72 per cent), especially when it comes to depression, psychosis, anxiety, and stress disorders. After researching about suicide in prisons, I gained a deeper insight to suicide in general.

19

Postvention: Loss of a Loved One by Suicide and the Stigma that Follows

The term 'postvention' is used to describe activities developed by, with, or for people who have been bereaved by suicide to support their recovery and to prevent adverse outcomes, including suicide and suicide ideation. The legacy of suicide remains with the victim's family, friends, work colleagues, and many others long after the deceased has left them. The impact is far reaching, and the trauma does not only affect those who are directly connected. When compared to people bereaved through other causes, those bereaved by suicide are at an increased risk of suicide, psychiatric admission, and depression. The risk of suicide attempts within the family is heightened and social functioning tends to falter. The number of people touched by the act of suicide runs far and wide, especially if the victim is a young person in the prime of their life. When this happens, suicide can spread like a contagion, and a cluster of deaths can follow. Suicide encourages more suicide when grief becomes unbearable and idealisation hits those left behind. I know this is true. I have had real suicidal thoughts several times since Anna died. My crisis began immediately after I heard the words 'Anna has hung herself', whereas her younger brother fell apart eighteen months later. How we deal with grief is unique to everyone.

Whilst there are organisations and charities that offer great support to the bereaved, there needs to be more affordable counselling for families and first responders, such as police and paramedics,

as well as for innocent passers-by who happen upon a suicide whilst going about their daily business. Train drivers are traumatised by 'jumpers'—what a horrifying thing to happen all in a day's work—and teachers and school friends and faith and social groups of victims are left shocked and bewildered. The effects can either be short or long term, depending on the circumstances. The type of support and how long it will be needed varies from person to person. The point in time at which people seek help also differs widely. It could be right away or further down the line, especially, as I mentioned earlier, around anniversaries and family events.

Although GPs and health workers have been trained in how to support the bereaved, more must be done in this epidemic of suicide we have witnessed during the Covid lockdowns. I came across a booklet entitled *Beyond the Rough Rock* put out by the charity Winston's Wish. It offers little nuggets of wisdom for adults who are supporting children and young people who have been bereaved by suicide. In it, one bereaved father wrote, 'I think many living with loss know of nothing more powerful, as a force for healing than to share with others bereaved by suicide and the knowledge we are not alone.' I guess this was why Erin Pizzey and I struck up an immediate close bond when we knew we were in the same boat of grief; the fact that we both missed our loved ones who had left us behind united us. We sat for hours talking about our lost loved ones, and the sense of sharing was palpable. Hours passed in what seemed minutes. We felt we had known each other forever. Something similar happened when Billy first opened up to his GP and then arranged some counselling. I witnessed an immediate change in his mood. He had made an important connection.

We also need to be thankful for the brilliant books written by the great psychoanalysts of our time that speak of everything from mild depression and anxiety to loss and bereavement to deep psychological therapies and also for the easily accessible self-help books dealing with separate mental health issues, such as anger management and self-awareness. Never underestimate how much you can learn from a book, and always know a self-help group can be a lifeline.

Suicide is that last gut-wrenching silent scream for help.

Suicide is our exasperation at not being heard.

Suicide is our last rage at our world.

Suicide is pent-up frustration and the end of a road filled with disappointment and hurt.

The danger list for suicide risk includes boredom, intolerance, frustration, avoidance, anger, rage, disappointment, procrastination, depression, hyperactivity, obsession, anxiety, grief, injustice, physical pain, heartache, guilt, shame, embarrassment, feeling misunderstood, impulsivity, and a desire for payback or revenge.

And the mind screams, *I can't take anymore. I must avoid this misery. I'm useless. I'm worthless. Nobody understands me. I give up. You would be better off without me.*

The root of the torment for people affected by the suicide of a loved one is always the question—*why*? What was the final straw that broke the camel's back? It may have been one last small rejection that ignites a former heartbreak. It may have been that pervasive rumination ignited by a punitive internal voice that has the final say.

So, if you are edging towards acting out a suicidal impulse, stop, breathe, and focus on the following: Try a new way of communicating. Don't let an impulse rob you and your loved ones of you. Curb your anger and frustration, be kind to yourself, be empathic with your terrified family, breathe slowly, distract yourself, and breathe again. Believe it can get better. Instead of killing yourself, metaphorically kill your internal saboteur.

With hindsight, I can see that my daughter believed she had to end her life in this world, as everything and everyone felt alien to her. She knew she was loved very much, but she still felt alone and isolated and worthless and disappointed. But I still can't help thinking that fear and anger were the dominant emotions that drove her to end her life. Her feelings of worthlessness and of being a burden were high, and she never really did learn how to love herself, but her frustrations and impulsive urges can never be underestimated.

We must never give up trying to find a language that the suicidal person can grasp onto in order to find a small spark of relief or hope. Once the lightbulb flashes on, they can begin to challenge the negative thoughts with positivity. New dialogue will begin to fill the spaces left by the now destroyed negative inner voice, and as night follows day, they can take baby steps towards managing a 'good-enough' life.

It is *vital* that there be somebody who can reach the suicidal person and connect with them through meaningful dialogue if change is going to be possible.

Speak—Connect—Redirect

20

Emotional IQ

'Emotional IQ' has been a buzz phrase for some years now. I like that we can focus on the emotional self as well as the intellectual brain. Whether we write with our left or right hands is down to the mapping in the hemispheres of our brain. The way our hormones and electric currents flood our brains is also unique to us and physically driven. Our personalities and how they grow or remain stagnant will usually depend on our individual interpretations of what we are seeing, hearing, and taking on board. Our feelings and our abilities to empathise, to go the extra mile to try to understand other people's perspectives, are what it takes to create harmony. To me, emotional intelligence is everything. To my daughter, it was everything.

I'd rather she had lived her short thirty-seven years with this blessing than a whole lifetime in ignorance. Most things in this world are bigger than us mere humans. Mother Nature always has the last word.

Part of Anna's loneliness in her last few years was caused by her missing Manu. She was frustrated that she wasn't living full time with her soulmate—the man she had finally been able to share her heart with and with whom she felt safe and whole. Her first love was undoubtedly art; in Paris she found a home where she felt she belonged. Her then happy and stable life afforded her the freedom to trust her instincts, let down her usual guard, and ease her personal boundaries. That, together with a healthy body weight and a confident mind, enabled Anna to merge with

a boy she loved everything about. His looks, his quiet nature, his love of art, his disinterest in material goods all fit perfectly into her ideas of what was good about a man.

Anna was not one for falling in love—her art and her creativity fed her soul. Yet, when you think about Anna's life story, all of her internal complexity, and her view of our world, it will not surprise you that brick by brick, her defensive wall began to trap her and cause her to disengage first from Paris and then her boyfriend. When Paris was no longer safe, she still trusted Manu and her feelings for him enough to move to another location. But when that location was not 'amazing' and her grandparents got sick in the UK, she felt justified in coming home to be with us.

I firmly believe that Anna was scared of herself more than anyone else; she knew that the person who could do the most damage to her was herself. Her low self-esteem kept her in such a negative mindset that I feel her fear of failure was coupled with a fear of success—as bizarre as this sounds, it's not actually that uncommon.

Our goals are so basic and so very simple, yet this striving in a difficult world can be exhausting, and happiness seems to be as elusive as the butterflies that dance around my daughter's grave. Still, the life wish and death wish compete for supremacy all our lives. Just as we are propelled into this world by nature's contractions, we are propelled forwards through birth to death—from the cradle to the grave.

Jewellery section

DEAR MA, JUST TO SAY I love you

BY THE TIME YOU RECIEVE THIS
LITTLE COLLAGE, I MADE WHILST
THINKING OF YOU & IN RESPONSE TO!
'GIRL SHIMMER MORNING AFTER
POPPY FOLDS RED' PART OF MY
RED PROSE'S COLLECTION OF
DRAWINGS THESE PAST DIFFICULT
MONTHS, NOW LIVING ALTER
RECOVERY WITHOUT THOSE PILLS
& THE MANIA FELT AFTER MY
DETOX. I WOULD LIKE TO SAY
THANK YOU FOR YOU & TO HAVE
THOUGHT FULLY POSTED ME THE
TREASURES THAT HELP ME REMEMBER
SPECIAL TIMES WE SHARED, AS...
YOU'LL BE HOME & I HOPE THAT
SPAIN FED YOU TRANQUIL MOMENTS

'A note to mum'

I am safe
With family
Food dished out to me, the English splash
Porcelain plate
Buttery mash and chicken
Soggy salad... the nice kind
Broken pizza.
Sisters in hoodies under blankets
And, mummy in the kitchen cooking lemon cake.

poem entitled 'before anorexia'

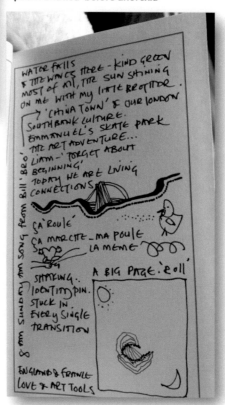

IN THE STUDIO CLOSE BY TO OUR JEWELS
& MATURING... HEALING... LOVING TIME IN
MONTPARTRE. A SPECIAL KERNAL, THE
BASE; WHICH I KNOW YOU FEEL 'CLOSE TO',
WITH SOUL FIGHTS
'US'
MY HOME FOR NOW... YOUR HOME.
NOT A DAY PASSES WHERE I FEEL THAT y
THE LOVE OF MY LIFE ARE TOO FAR.
OPPOSITE ENDS OF THE TRACKS,
& YET STRONGER
'US'
SEASONS COME & GO...
YOU & ME, SET STONES FOR AN EVER BLO
AROUND THE OUTSIDE,

'Mother Daughter bond'

WATER FALLS
& THE WAVES THERE - KIND GREEN
MOST OF ALL, THE SUN SHINING
ON ME WITH MY LITTLE BROTHER.
→ 'CHINA TOWN' & OUR LONDON
SOUTHBANK CULTURE.
EMMANUEL'S SKATE PARK
THE ART ADVENTURE...
LIAM - 'FORGET ABOUT
BEGINNING'
TODAY WE ARE LIVING
CONNECTIONS

ÇA 'ROULÉ'
ÇA MARCHE - MA POULE
LA MÊME

SHARING...
IDENTITY PIN.
STUCK IN
EVERY SINGLE
TRANSITION

A BIG PAGE 'ROLL'

ENGLAND & FRANCE
LOVE & ART TOOLS

'Little Brother' to go in Poetry section

The **Anna M Wright Art Foundation** aims to be an empathetic ear and a source of therapeutic help to anyone feeling suicidal, as well as to those bereaved by suicide. It will also act as a networking service with a quarterly newsletter containing information and education about ALL mental health issues..

Art and art therapy, poetry, song-writing, and creative writing workshops, have proved to be hugely beneficial in the mental health arena and Anna's foundation aims to focus on building awareness via artistic activities.

Self awareness leads to a higher sense of self-esteem and honest and open communication redirects feelings of anger and frustration away from the need to harm yourself. Dangerous acting out can and does ruin many lives. Committing suicide is the biggest act of self-destruction. It is a silent roar which, unheard, will build and explode like a volcano.

People must learn new healthy ways of communication - especially when in crisis. There are so many young people who are desperately trying to fit into society, but don't know how. Every knock-back chips another piece of self-esteem away and builds another layer of a dangerous defensive wall.

All copies of this book, plus prints of Anna's art, poetry, and other merchandise will help raise funds for 'The Anna M Wright Art Foundation'.

Books for Further Reading

1. *The Drama of Being a Child* by Alice Miller
2. *The Gift of Therapy* by Irvin D. Yalom
3. *Playing and Reality* by D.W. Winnicott.
4. *A Grief Observed* by C. S. Lewis
5. *Anxiety* by *Ricky Emanuel* (part of the series Ideas in Psychoanalysis)
6. *Family Therapy* by Mark Rivett and Eddy Street
7. *This Way to the Revolution*—Erin Pizzey
8. *Suicide in Prisons: Prisoners' Lives Matter* by Graham J Towl and David Crighton
9. *The Art of Loving* by Erich Fromm
10. *A Million Little Pieces* by James Frey
11. *My Friend Leonard* by James Frey
12. *You Will Not Have My Hate* by Antoine Leiris
13. *Understanding the Twelve Steps* by Terence T. Gorski
14. *Insomniac Dreams* by Vladimir Nabokov
15. *Grief, Is the Thing with Feathers* by Max Porter
16. *Wilderness: The Lost Writings of Jim Morrison* by Jim Morrison
17. *Patti Smith: American Artist* by Frank Stefanko
18. *Jonathan Livingston Seagull: A Story* by Richard Bach
19. *Paris Echo* by Sebastian Faulks
20. *Grief Works* by Julia Samuel

Helpful Charities

1. The Anna Freud Centre— www.annafreud.org
 Charlie Waller Trust— www.charliewaller.org
2. Winston's Wish - www.winstonswish.org.uk
3. Campaign Against Living Miserably (CALM)—www.thecalmzone.net
4. Papyrus Prevention of Young Suicide—email: pat@papyrus-uk.org
5. BEAT Eating Disorders Helpline—Tel: 0808 801 0677
6. National Suicide Prevention Alliance—www.nspa.org.uk
7. Men's Health Forum National Suicide Prevention Alliance (NSPA)—www.menshealthforum.org.uk
8. Samaritans—Tel: 116 123
9. Rethink Mental Illness Advice—Tel: 0808 801 0525